POSTCARD HISTORY SERIES

South Carolina Postcards

VOLUME VIII

CAMDEN

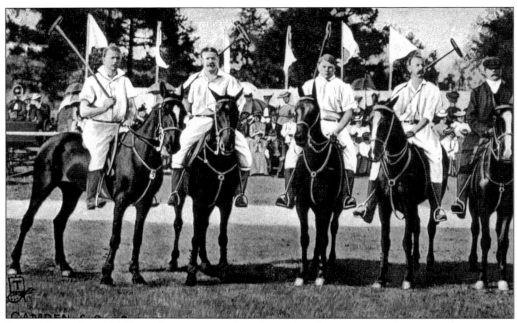

POLO TEAM, [c. 1908]. Polo was introduced to Camden in 1898 by Roger L. Barstow (1875–1961), a wealthy winter resident. He had his own string of 22 ponies. The Camden Polo Club was established to organize tournaments and sponsor horse shows. The polo fields were near the Kirkwood area so that Northerners wintering in Camden could enjoy the sport. The postcard portrait above was taken in 1906 when Camden played Orlando, Florida. The team players were, from left to right, Rogers L. Barstow, Syd Smith, A. Dalton Kennedy, K.G. Whistler, and T. Edmund Krumbholz (referee).

FRONT COVER:

MEMORIES OF CAMDEN, [c. 1880s]. This 1880s image of William S. Alexander's "home orchestra" shows his extended family positioned for an open-air recital. It was photographed by William himself. On the left side, his wife Luella is seated in front of a piano; behind her, Thomas holds a violin; William holds a flute; and Annie, seated behind, has a violin. Seated in front with a violin is Elizabeth, Donald holds a trumpet, and Isaac Henry has a base violin. Since radio, television, or movies did not exist, prosperous families of that era took music lessons and gave recitals as family entertainment. William Alexander operated a photographic studio in Camden (1876–1891). He made numerous portraits and documented cultural scenes and various views of Camden.

BACK COVER:

["CAMDEN, YESTERDAY AND TODAY" 1925]. On May Day 1925, several hundred school children and numerous adults performed a historical pageant entitled "Camden, Yesterday and Today." The view portrays George Washington's visit to Camden on May 25, 1791. The actors included Bissell Kennedy, who portrayed Washington, and Mrs. S.C. Clyburn, who played the part of a Camden hostess. John A. Sargeant photographed the events.

2

POSTCARD HISTORY SERIES

South Carolina Postcards

VOLUME VIII

CAMDEN

Howard Woody and Davie Beard

ARCADIA

Published by Arcadia Publishing,
an imprint of Tempus Publishing, Inc.
2 Cumberland Street
Charleston, SC 29401

Printed in Great Britain.

Library of Congress Catalog Card Number: 2002117618

For all general information contact Arcadia Publishing at:
Telephone 843-853-2070
Fax 843-853-0044
E-Mail sales@arcadiapublishing.com

For customer service and orders:
Toll-Free 1-888-313-2665

Visit us on the internet at http://www.arcadiapublishing.com

Dedication

For Arlene, my patient, ever-loving wife. —H.W.

For Ned and Meta Beard, my parents, for their encouragement

in discovering Camden's past. —D.B.

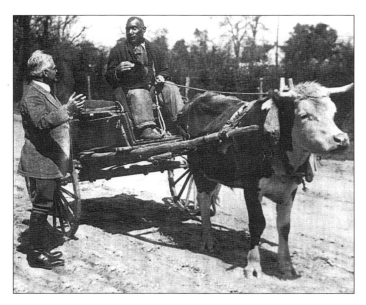

[KIRKOVER & WILLIAMS, C. 1910]. Harry D. Kirkover (1874–1958), racing enthusiast, (left) speaks to William Williams (1886–1952), a well-known Knights Hill farmer who is following the local custom of removing a hat when speaking to others. Williams used an ox-wagon to transport produce and owned 27 acres, which he inherited from the original 100-acre property owned by his father Daniel Williams and located in the Old St. Paul Church segment of the Knights Hill area.

CONTENTS

INTRODUCTION

The search for historical images reflecting the evolving culture of South Carolina at the beginning of the 20th century continues with this eighth volume on historic Camden. This series began with related multi-county volumes following a path that started in Charleston and shifted south to Beaufort and the Low Country (volume two) before moving to Aiken and the west central section (volume three). When this journey entered the Midlands, an unexpected amount of early postcard images reflecting daily lifestyles was uncovered; therefore, a decision was made to shift to single-county books beginning with *Lexington County* (volume four), *Richland County* (volume five), and *Newberry County* (volume six). When Kershaw County was surveyed, an extensive diversity of images from the Colonial, Revolutionary, and Civil War periods, along with late-19th century and pre-1935 views, was uncovered and thus two volumes were published. *Kershaw County* (volume seven) covered Native Americans, military, transportation, and rural Kershaw communities. *Camden* (volume eight) covers municipal, commercial, cultural, resort, sport, and mill subjects. Our search was for visual images that documented the uniqueness of this Midland town in South Carolina.

After Charleston was established, King George II of England gave instructions to Gov. Robert Johnson (1730) to mark out places for 11 inland townships on the rivers of South Carolina, which included the Wateree. England's Royal Council employed James St. Julien (1733) to survey a six-mile square township on the eastern side of the Wateree River, which was initially named Fredricksburgh after the Prince of Wales. By 1750, European families and a group of Irish Quakers began settling along the Wateree River near Camden. They were joined by Scotch and Scotch-Irish settlers who traveled south in covered wagons on the Great Philadelphia Wagon Trail from Virginia, Maryland, and Pennsylvania. Joseph Kershaw (1728–1791) surveyed a tract of 150 acres for William Ancrum in 1758 that included a site Kershaw called Pine Tree Hill. The name Camden, which was first used in 1768 by an act of the South Carolina Assembly, came from colonial rights champion Charles Pratt, Earl of Camden. The courthouse and gaol (jail) were built in 1771. The Legislative Act of 1791 officially established the town (the second after Charleston) and Camden became the oldest incorporated inland town in the state. Joseph Kershaw, the father of Camden, established his mercantile business, a gristmill, sawmill, and other enterprises by 1760.

In the Colonial era of the 1750s, the Church of England was the official church of the colonies. Camden was included in St. Mark's Parish, created by the Royal Assembly in England. Charleston-based clergy would make only irregular visits inland to the town. During the Revolutionary period, some of the patriots regarded the Church of England as an imperial institution with an intolerable past. Proselytizing Protestant evangelists were not yet officially sanctioned and initially could not meet in public halls, but itinerant ministers from the Presbyterian, Baptist, and Methodist denominations visited Camden in the 1770s and 1780s and left converts who eventually formed congregations. By 1808, parishioners of the Church of England began reorganizing under the Episcopal name in order to reestablish themselves as an American entity independent of England. Ministers of the several denominations often became teachers.

Camden established one of the earliest school acts in the state. The Camden Orphan Society was organized July 4, 1786 and was incorporated by an act of the assembly on February 27, 1788.

Its purpose was to erect suitable buildings for the reception, education, and support of "poor orphans and other poor children in distress and for the moderate relief of such members as may want it." The society supported four orphans annually. In 1810, the society established a separate free school, and the state eventually followed suit by creating a free school system in 1812.

Camden owes its early existence to its location below the fall line of a navigable waterway. Travel to Charleston was first conducted on the Santee River by way of its mouth (1786–1795), and steamboat travel was in use by the mid-1830s. Land travel to Charleston included a stage line in 1824, and by 1848 railroad travel used an indirect spur line that connected Camden to Columbia and Charleston.

In 1816 the *Camden Gazette* stated that Broad Street was one mile long with 120 dwellings, 30 retail and wholesale stores, four houses of worship, a large framed courthouse, a brick market, library room, grammar school, brick arsenal, jail, and two fire-engine houses. In 1829 a great fire destroyed 85 buildings, which was then followed by major fires that repeatedly gutted the business district. However, Camden was rebuilt even larger after each incident, and the population of Camden, Kirkwood, and the Factory Village was 1165 in 1849. Camden was third in the state in commerce and wealth by 1854.

From the Colonial and Revolutionary eras through the Antebellum, Civil War, and Reconstruction periods, Camden produced and attracted individuals with skills that contributed to the evolution of South Carolina. Several of these will be mentioned in this volume. In particular, I.B. Alexander, a skilled miniature painter, and his son William, a very gifted photographer who recorded several cultural facets of late-19th century Camden, are documented in some depth. The missionary zeal of Mather Academy's education of African Americans was also documented and the diverse images were carefully protected. As the 20th century neared, Camden's industrial base included cotton mills and their villages and operatives, which added to the town's economic base. And like Aiken, the climate, quality of life, and rail accessibility attracted Northern financiers and industrialists who wintered in Camden and developed equestrian hobbies, adding a new cultural facet to the community.

This volume begins by presenting views of the municipal, business, cultural, resort, sport, and industrial aspects of the town. Camden's stores produced a normal level of commercial postcards that were sold by retailers such as Zemp's Drug Store. The images found in this volume came from private postcard collectors, such as Davie Beard, the Camden Archives and Museum; the Kershaw County Historical Society; the University of South Carolina archives and postcard collection; and the albums of those individuals with Kershaw roots and interests. The photographer's images were used on postcards and also in advertisements, newspapers, and other publications so that the photographer could make as much money as possible from each negative. The selection criteria included whether or not the subject had been seen before in South Carolina postcards series, and its historical or cultural value for South Carolina history teachers, students, and the general public in 2002. Members of historical societies located images in local private albums and the editors copied them at public meetings.

The scales of the pictures on the cover and within the book have been altered to conform to the page layout. Additionally, "titles" that appear on the front of some postcards begin each image's accompanying caption; where views have no title or it is incomplete, the authors have created one and inserted it between brackets.

The object of the previous Postcard History Series books has been to produce a body of images that reflect the lifestyles and culture of a community before the 1930s. We hope that the same level of edification and enjoyment has been found in this volume as well.

Howard Woody and Davie Beard

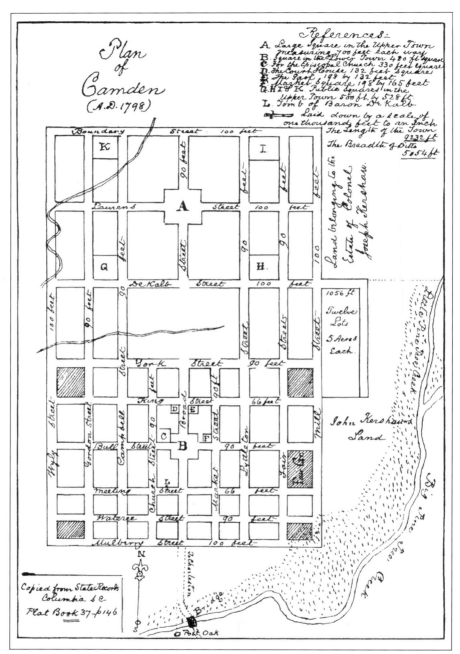

PLAN OF CAMDEN, [1798]. The boundaries of Camden as first defined in the plan of 1774 remained unaltered until 1798, when they were extended by a legislative act. The boundaries of the eastern side began at the intersection of DeKalb Street and the Little Pine Tree Creek bed. They continued on down to Mulberry Street, which became the southern boundary, and finally over to Wyly Street, which was the western side. This plan included a vacant square from which a stream flowed. R.L. Champion eventually drained it and established Rutledge Street. By 1872 the northern boundary was moved to Chesnut Street. (*Historic Camden*, volume 1.)

One
COMMERCIAL DISTRICT

The Camden site on the east side of the Wateree River was first settled by a few people in 1730–1740, and then by a colony of Quakers from Ireland in 1750. In 1758, Colonel Joseph Kershaw founded a town called Pine Tree Hill, laid streets and squares, and later renamed it in honor of Lord Camden. In 1900, Camden had a population of 2,441 and was still recovering from the destruction of the Civil War. However, progress was occurring and the town was looking to the future. Two railroads served Camden and its two cotton mills, oil mill, coffin factory, and brickyard. Telephones were being installed. Camden's Water and Light Company laid water mains and erected a powerhouse for electricity that would replace kerosene lanterns on Broad Street for businesses and homes. The two banks, two newspapers, numerous merchants, several churches, three hotels, and an opera house served citizens throughout the city. Camden had a bright future.

[CAMDEN BANK NOTE SCENE, 1836]. This engraved scene of the market and courthouse at the junction of Broad and King Streets was placed on a $10 bank note issued by the initial Bank of Camden in 1836. On the left stands the second market, built *c.* 1816, with its tower, built *c.* 1825. The market was on the ground floor, while the upper floor served as town hall, council chambers, and site of the Library Society. The Robert Mills Courthouse, with its initial six-column facade, is opposite on the right. The house in the center is unidentified.

9

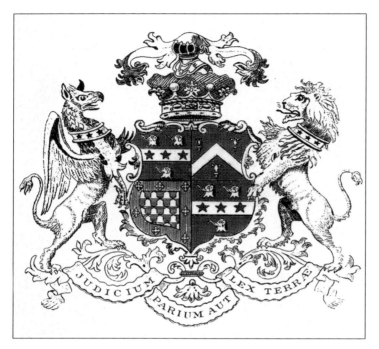

[CAMDEN FAMILY'S COAT OF ARMS, *c.* 1780s]. Charles Pratt's coat of arms (shown left) reflected his ideals when he was chief justice of common pleas in 1761. This emblem was created when he was elevated to the peerage and became Baron Camden in 1765 and then Lord Chancellor in 1786. The Latin text *Judicium parium aut leges terrae* comes from the Magna Carta and translates as meaning "laws of the land." Pratt championed colonial rights and liberty of the subject and was opposed to the taxation of the colonies.

[LORD CAMDEN, *c.* 1780s]. Charles Pratt (1713–1794) was born at Careswell Priory, Devonshire, and attended Eton. Pratt became a prominent barrister and was appointed attorney general in the English Parliament. Pratt became the first Baron Camden, which was derived from his estate, Camden Place, in the county of Kent. Later, Parliament changed his title to Lord Camden. He often spoke on behalf of the colonists.

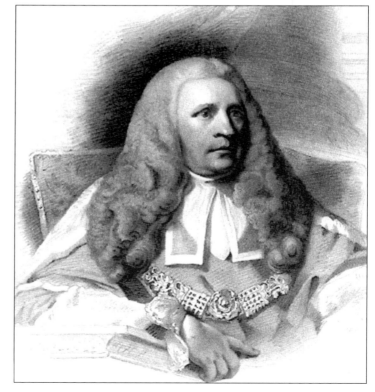

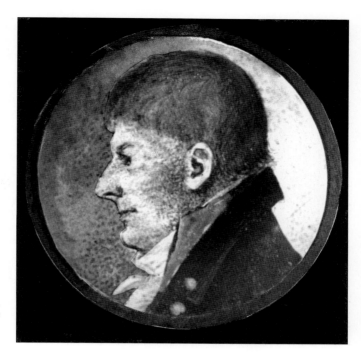

[MINIATURE PAINTING OF JOSEPH KERSHAW, C. 1780].
Joseph Kershaw (1728–1791) was born in West Riding in Yorkshire, England and came to Camden in 1758. By 1760 he started his fortune by milling "Carolina" flour, which was shipped to Charleston. Kershaw also built saw mills and gristmills, indigo works, and mercantile businesses. He was a staunch patriot and was imprisoned and deported when the British took Camden. After the war Kershaw returned to Camden, but by then he had lost most of his fortune and died in 1791. Kershaw is called the "father" of Camden, and Kershaw County is named after him.

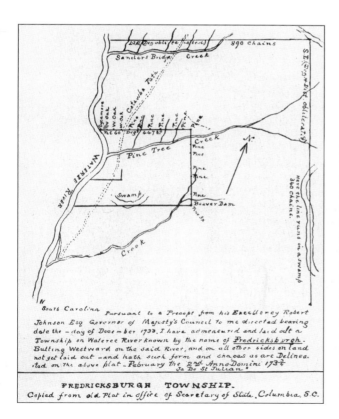

FREDRICKSBURGH TOWNSHIP, [MAP, 1733]. In 1733, England's Royal Council employed James St. Julien to survey a six-mile square township containing 20,000 acres on the eastern side of the Wateree River. Surrounding these townships was a 12-mile square farming area, which would be reserved for immigrants. Each family would receive a town lot and 50 acres for each member of the family. The township was initially named Fredricksburgh after the Prince of Wales. This is the initial map that documented the site that St. Julien surveyed. (*Historic Camden*, Vol. 1).

11

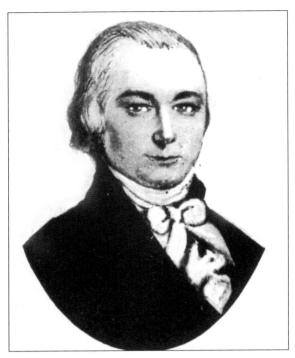

[JOSEPH BREVARD, *c.* 1800]. Joseph Brevard (1766–1821) was born in Iredell County, North Carolina. Brevard entered the Continental Army in 1782 as a lieutenant in the North Carolina regiment and remained until the end of the war. He settled in Camden, and in 1789 the legislature elected him sheriff of the Camden district, which covered seven counties. Brevard passed the bar in 1792. In 1801, he was elected a judge of the highest state court where he compiled the state's laws up to 1814. Brevard was elected to a seat in Congress from his district in 1818 but retired in 1820. He died in 1821.

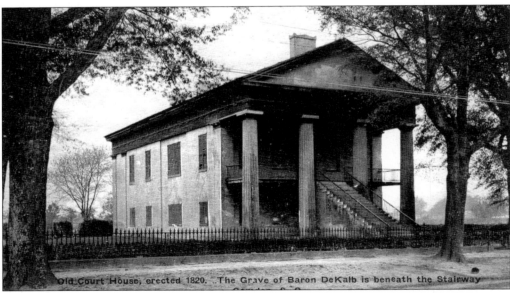

Old Court House, erected 1820. The Grave of Baron DeKalb is beneath the Stairway

OLD COURTHOUSE, [*c.* 1906]. The third courthouse—designed by Robert Mills (1781–1855)—was finished in 1826 and placed on the same foundation as the previous two at King and Broad Streets. The portico was supported by six brown sandstone Ionic columns. In 1847 changes were made inside and out, and the six columns were replaced by four larger Doric columns. The enclosed structure was 43 by 62 feet. Small rooms for county business make up the ground floor and the courtroom is on the second floor. It still stands at 613 Broad Street and was renovated in 2002.

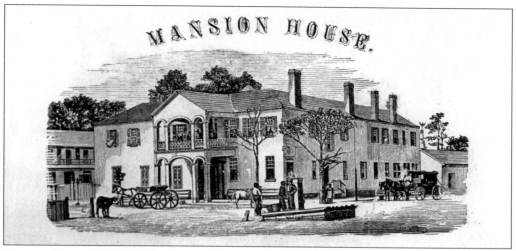

MANSION HOUSE, [1870s]. The above advertisement for the Mansion House has also been seen with a Kershaw House imprint. The building may have initially been called "Cross Keys" by William McKain in 1829. The illustration portrays a major two-story hotel on the southwest corner of Broad and DeKalb Streets when E.G. Robinson (1813–1880) was the manager. The public well at that intersection is shown in the foreground. The structure burned in the 1874 fire.

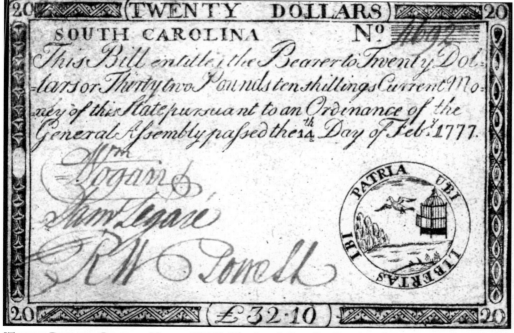

[TWENTY DOLLARS, COLONIAL MONEY, 1910]. The South Carolina Provincial Congress selected state officials on March 6, 1776. The general assembly authorized a series of bills on February 14, 1777 for colonial trade. The $20 bill is signed by William Logan, Samuel Legare, and R.W. Powell. A Charleston engraver created a set of metal plates from which paper currency was printed for use in this colony. Few original notes exist in 2002. Examples like the one above were photographed and printed on postcard stock and were found in a Camden postcard collection.

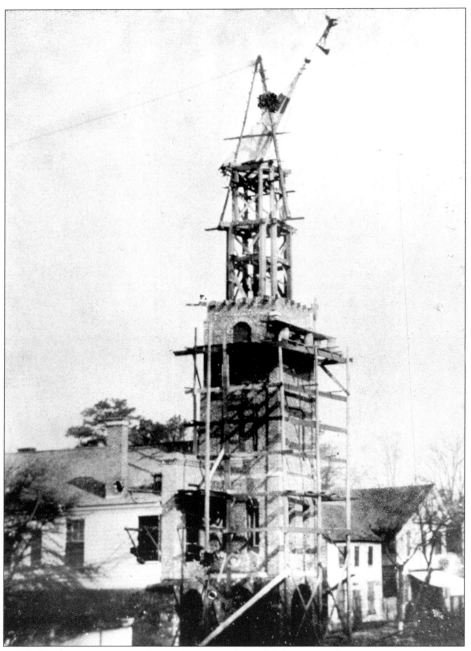

[CONSTRUCTION OF THE SECOND TOWN TOWER, 1859]. The first town frame tower was in existence by 1826; it was an imposing spire and had clocks and a weather vane. The scene above shows the building of the second tower near 1021 Broad Street (west side). It was a freestanding structure in front of the market building and over the sidewalk, and it stood until 1886. The spire had clocks, and above them was an observatory surmounted by a weather vane with a 6-foot Native American image of King Haiglar. The second tower and building was razed after the third was built and the weather vane hoisted to its top.

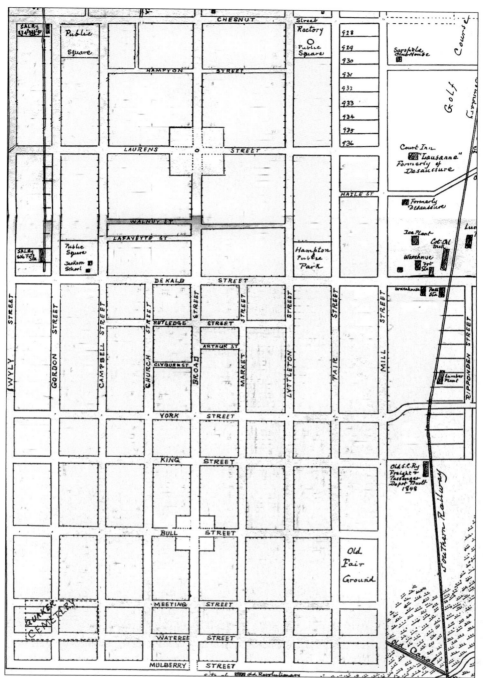

[**MAP OF CAMDEN, 1920s**]. This 1920 map of Camden shows the layout of the city, names of the streets, and the evolution of the business district, residential area, and adjacent railroad sections. The top of this map is north, with Broad Street running south. Street numbers in this volume use the number system listed on the 1912 Sanborn Insurance Company's fire map. (*Historic Camden*, vol. 2).

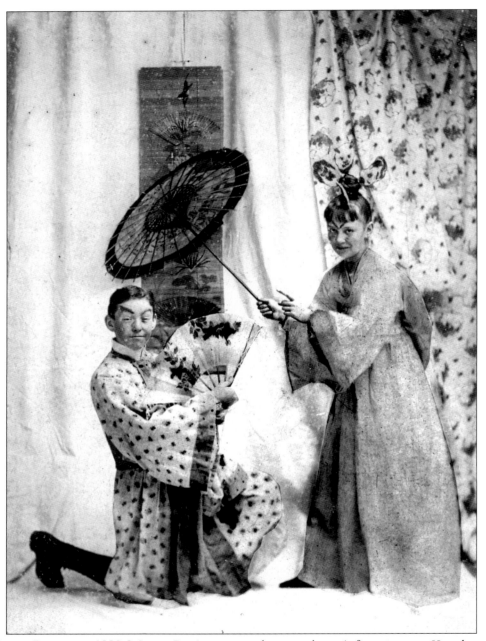

[MIKADO PLAYERS, C. 1880s]. James Brasington was the opera house's first manager. He selected both the touring and local plays, operas, and cultural events that were presented to Camden's society. The image above shows two Camden actors: Chu Doe, a gardener for George G. Alexander, and a local lady dressed for a Mikado performance (photographed by Alexander). The opera house's second floor auditorium was 40 by 50 feet and seated 360 opera chairs; the third floor gallery contained yet another 180 chairs. The stage was 40 feet wide and 20 feet deep with a painted curtain that hid four dressing rooms. This image is another example photographed by the William Alexander studio that documented cultural life of Camden.

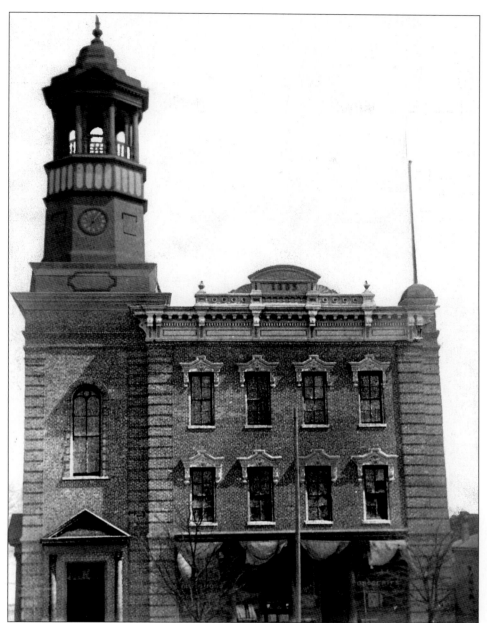

[OPERA HOUSE, *c*. 1900]. The third opera house at 952 Broad Street (east side) was built in 1886 at a cost of $21,000 and was used as a theatre and municipal office until 1964. J.H. Devereux was the architect, J.S. Allen was the builder, and Capt. J.C. Rollings was in charge of its construction. The structure had a 60 foot street front and extended 100 feet back. Its 118-foot high free-standing clock tower was placed over the sidewalk on the Rutledge Street corner of the building. Its retail ground floor space housed the Hirsch Brothers store in 1896, and the front section was occupied by council chambers on the second floor. The city hall used portions of this structure until the 1956, when a new building was constructed. Only the tower remains in 2002. In 1964 the opera house portion of the structure was razed and rebuilt into a department store.

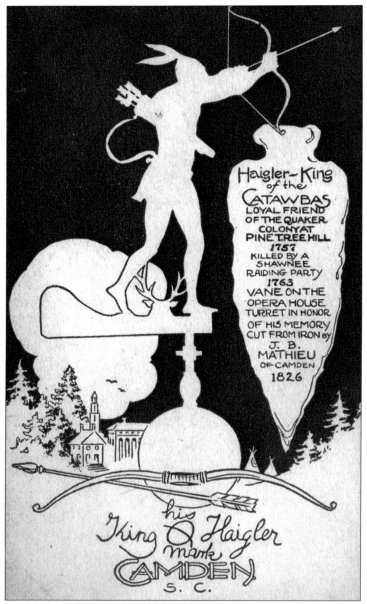

The following text appears within the illustration:

Haigler-King of the CATAWBAS LOYAL FRIEND OF THE QUAKER COLONY AT PINE TREE HILL 1757 KILLED BY A SHAWNEE RAIDING PARTY 1763 VANE ON THE OPERA HOUSE TURRET IN HONOR OF HIS MEMORY CUT FROM IRON BY J. B. MATHIEU OF CAMDEN 1826

his King Haigler mark CAMDEN S. C.

[HAIGLAR- KING OF THE CATAWBAS, c. 1915]. Haiglar (c. 1730–1763) was a tribal leader of the Catawba Indians in 1751 and became their king in 1752. Haiglar became friends with Camden's Quaker leader Samuel Wyly. When war broke out, he and the Catawbas defended the colonists. King Haiglar was killed in 1763 and was mourned by both colonists and Catawbas. J.B. Mathieu, a French merchant living in Camden, designed the 6-foot iron weather vane (above) in Haiglar's honor in 1826, and it was placed atop the market tower across from the Mills courthouse. Since Haiglar was considered "the patron saint of Camden," the weather vane became the town's guardian. In 1859 it was moved to the uptown town hall and finally to the top of the 952 Broad Street opera house tower in 1886. The original is now in the Camden Archives and Museum, and a replica sits atop the tower.

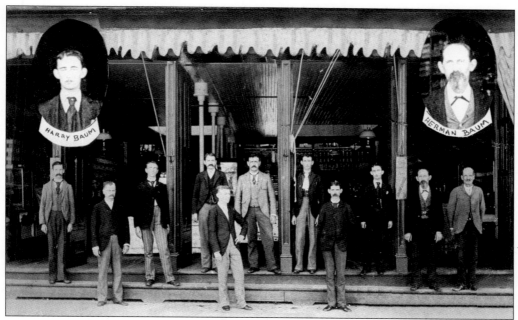

[BAUM BROTHERS' STORE, 1890]. The three Baum brothers were German immigrants from Schwersenz, Prussia. They settled in Camden just before the Civil War and opened a mercantile store in 1850. Each served in the Confederate service. After the war Herman (1828–1899) and Mannes (1869–1910) operated a large mercantile business at 1000 Broad Street until the time of their deaths. Later, Harry (1873–1947) worked there. The 1890 picture above includes (from left to right) W. Billings, S. Rhame, E. Lewis, C.W. Medlin, W.D. Goodale, L. Schenk, M.H. Baum, C.R. Lewis, B.H. Baum, W.C. Gerald, and W. Billings Sr. In 1902 they stocked buggies, groceries, dry goods, and hardware.

[OLD TAVERN, *C.* 1930s]. The site of the old tavern was several lots north of the Mills courthouse at 721 Broad Street and was a popular public house for food and drink during the Revolutionary era. Carved above the door was "Entertainment for all—Man and Beast." It was listed either as a tenement building or vacant in the Sanborn Insurance Company's Camden maps from 1884 to 1912.

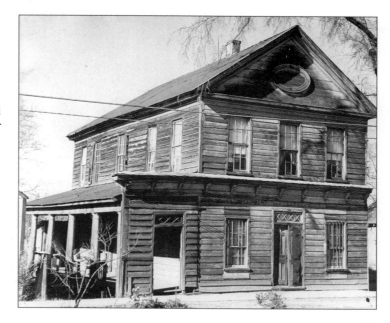

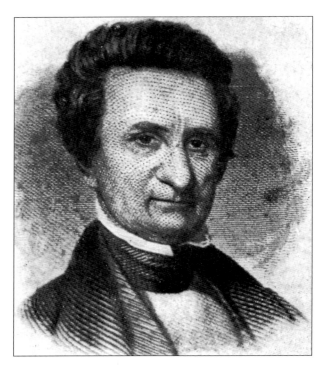

[WILLIAM McWILLIE, C. 1850S].
William McWillie (1795–1869) was
born at Liberty Hill, graduated from
South Carolina College in 1817, and
passed the bar in 1818. He was
elected to the legislature in 1830. In
its inaugural year of 1836, McWillie
was elected president of the first
Bank of Camden and remained in
that position for nine years. In 1840
he was elected to the state senate;
upon his reelection in 1844, he
championed a measure for state aid
in building the Camden branch of
the South Carolina Railroad.

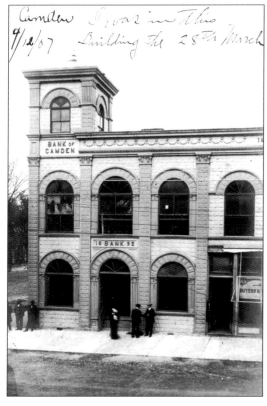

[BANK OF CAMDEN, C. 1907]. The first Bank
of Camden (1836–1865) was located at the
southwest corner of Broad and Rutledge
Streets and closed at the end of the Civil
War. The second Bank of Camden, in a
different building shown to the right, was
organized in 1888 with H.G. Carrison as
president and W.M. Shannon as vice-
president. As indicated on an 1894 Sanborn
Insurance Company's Camden map, this
bank was located at 1001 Broad Street, on
the northwest corner of Broad and Rutledge
Streets. This building no longer stands.

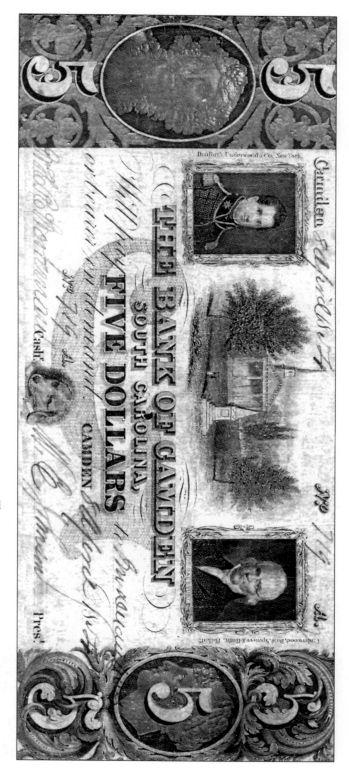

[FIVE DOLLAR BILL, BANK OF CAMDEN, 1854]. From 1836 until 1865, the Bank of Camden issued its own currency. This five dollar bill #719 was issued on April 8, 1854, when W.E. Johnson was president and W.H.K. Workman was cashier. The central image is of the Bethesda Presbyterian Church and the DeKalb Monument. The portrait on the left is of Gov. R.I. Manning and H.W. DeSaussure is on the right. Danforth and Underwood Company of New York and Underwood, Bald, Spencer, and Huffy of Philadelphia designed and printed this bill.

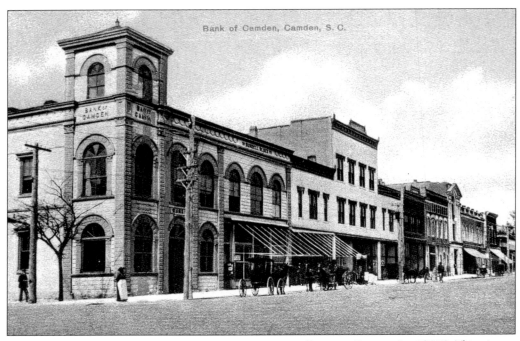

Bank of Camden, Camden, S. C.

BANK OF CAMDEN [*c.* 1907]. This view looking north shows the west side of the 1000 block of Broad Street from the intersection of Rutledge Street. On the left corner is the Bank of Camden (#1001) that was erected in 1888. The block continues with Springs and Shannon Enterprises at #1005, a hardware store (#1007), Burns Hardware Store (#1019), the Commercial Savings Bank (#1025), the Candy Kitchen (#1031), and the Loan and Savings Bank (#1039).

[CITY MARKET, *c.* 1890S]. A new market and town hall was built in 1859 on the west side of the 1000 block of Broad Street, north of the intersection with Rutledge Street. In 1886 the third opera house was erected on lot #1049 (952 Broad) on the southeast corner of Broad and Rutledge Streets. A new market, shown left, was erected on lot #1048 (946 Broad) south of the opera house. This market was razed in 1901.

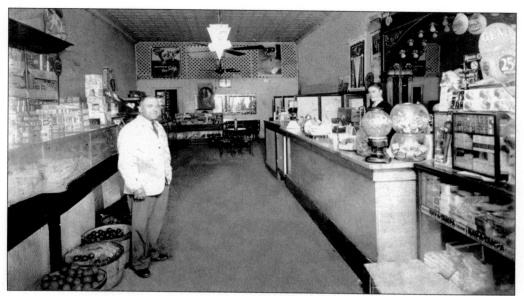

[INTERIOR, CANDY KITCHEN, C. 1930]. This interior view of the Candy Kitchen at 1044 Broad Street shows Theodore Beleos. The store made and sold many varieties of homemade candies (such as peanut brittle) and ice creams, which was sold at 5¢ for a single scoop cone. The soda fountain served cherry smash and cokes, lemon and orangeades, milkshakes, and malts. Baskets of apples and other fruit were sold. Comic books, magazines, and other related goods were also stocked.

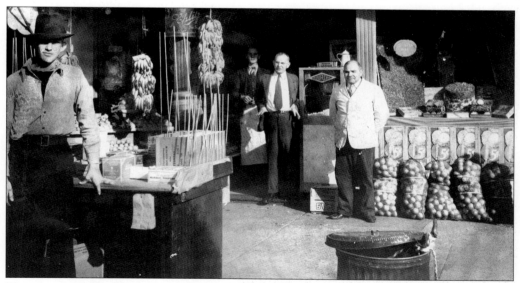

[EXTERIOR, CANDY KITCHEN, C. 1930]. The Candy Kitchen, owned by Theodore Beleos (1892–1968) was originally located at 1031 Broad Street. Later, it moved to 1044 Broad Street. Here Harry Berles and Theodore stand at the door. Guy Mayer is in front, selling fireworks, firecrackers, and sparklers. Not in view is a popcorn machine and a peanut parcher, whose aroma attracted customers off the street. This view shows the hanging stalks of bananas, bags of oranges, apples, and other fruits and vegetables that attracted other shoppers. Boxes of Lowney's chocolates and other candy are on display in their front window.

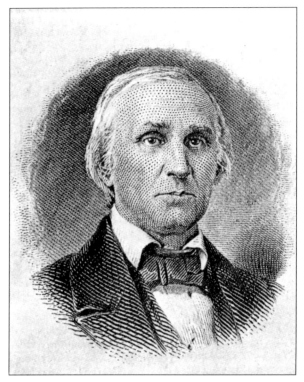

[THOMAS WITHERS, c. 1850s]. Thomas J. Withers (1804–1865) graduated from South Carolina College in 1825, was admitted to the bar in 1828, and then moved to Camden. He was first elected solicitor in 1832 and later served 20 years as a common law judge who sat at the court of appeals. Withers also acted as one of the Kershaw County delegates sent to the Ordinance of Secession Convention.

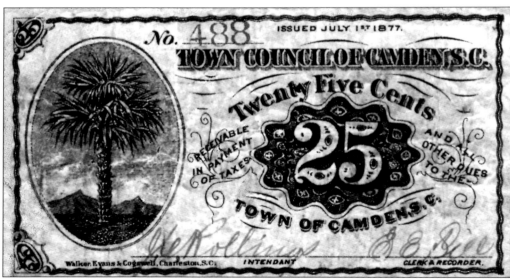

[TOWN OF CAMDEN, TWENTY-FIVE CENT BILL, c. 1877]. At the end of the Reconstruction era (1877), towns in South Carolina were granted permission to create paper money as a means to collect their fees and taxes. Walker, Evans, and Cogswell Company of Charleston (a major printing company for official state documents) printed this bill. The town council of Camden issued this 25¢ bill (#488) on July 1, 1877 when J.C. Rollings was the mayor and E.E. Sill was the clerk and recorder.

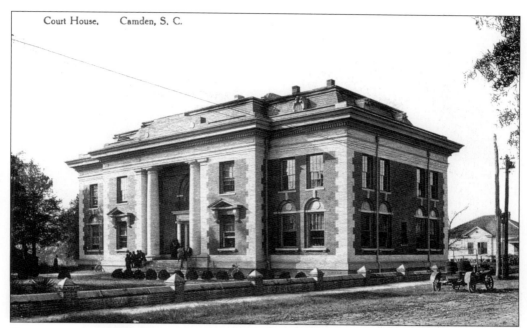

Court House. Camden, S. C.

COURTHOUSE, [c. 1908]. The architectural firm of Edwards and Walter of Columbia was selected to design the 1905 Kershaw County courthouse. T.C. Thompson and Brothers of Birmingham, Alabama constructed the building at a cost of $31,000. The courthouse, built on the old Lafayette House site on Broad Street, was completed on November 17, 1905. It was razed in 1966. The next courthouse was placed on this same site.

[SHERIFF R. B. WILLIAMS, c. 1900]. Ross Brooks Williams (1857–1924) was born in the Harmony section of Kershaw County. After the Civil War he worked in Arkansas before returning to Ridgeway. He farmed and taught school before he served as sheriff from 1892 until 1900. Here he is photographed standing in front of the courthouse. In 1914, Williams owned the Williams Hotel and the City Grocery at 1126 and 1128 Broad Street (respectively), across from the courthouse.

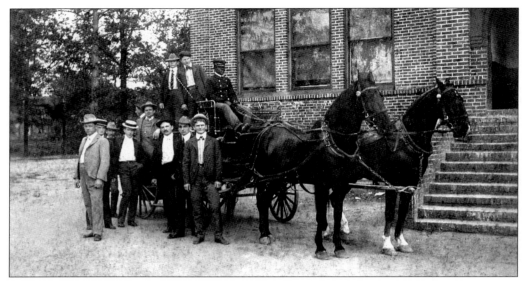

[CAMDEN'S FIRE WAGON, 1902]. Camden's fire companies included two fire engine houses (built in 1816), the independent fire engine company (1829), a hook and ladder company (1830), the hydraulic company (1833), the independent company (1837), and two African-American fire companies. The hand engine gave way to the steamer in 1884 and the waterworks came in 1897. The fire wagon shown above (1902) had a seesaw-type hand pump that forced water from city wells to the fire. The image above was taken in front of the graded school.

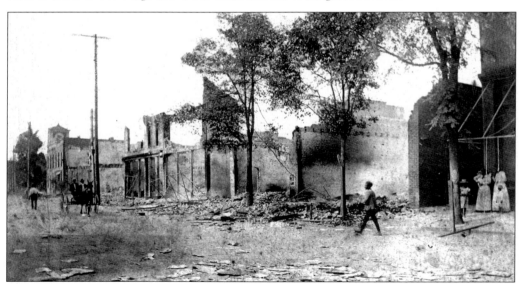

[FIRE RUINS, 1000 BLOCK OF BROAD STREET, 1902]. The July 1902 fire destroyed one block of nine stores on the west side and the new post office. Most stores recorded a loss of less than $2,000, but other stores were less fortunate. Dr. F.L. Zemp's Drug Store lost $4,000; Geisenheimer's Furniture Store lost $12,000; and W.H. Zemp's Clothing Store had $12,000 worth of damage. The fire occurred at an unfortunate time when the water and electric powerhouse was already destroyed and the piped water system was useless. Merchants and others removed goods and piled them in the street where the county's (national) Kershaw Guards protected them.

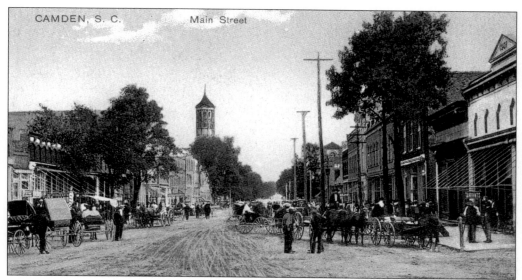

MAIN STREET, [C. 1908]. This postcard street scene shows the west side of the 1000 block of Broad Street (on the right), the same block that was ruined by fire in 1902. In 1897 the city began laying water main pipes from the business district to the site of the new water and light plant. With the water plant in place the city bought modern hose-and-reel firefighting equipment. In 1900 the two-horse fire wagon was housed on Rutledge Street behind the opera house. A 1902 fire destroyed the water and light plant, leaving the city without water or lights for a year.

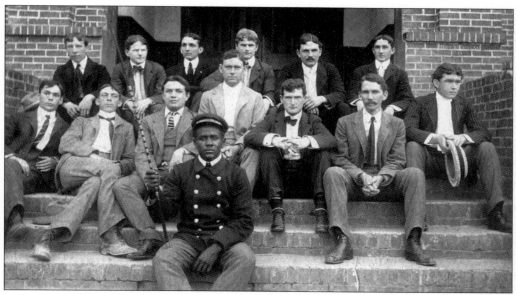

[FIRE DEPARTMENT MEN, 1902]. Camden had several major fires, one of which gutted two Broad Street business blocks in 1812. Another burned 85 buildings in 1829. Camden's business section had several large public wells that acted like reservoirs for fire fighting. The 1902 volunteers pictured above were, from left to right, (front row) C. Champion (driver), F. Zemp, W.R. DeLoache, W.A. Boykin, H. Watkins (fire chief), W.S. Burnet, G. Bruce, and R. McCreight; (back row) W. Young, G. Rhame, R. Zemp, B. Rhame, J. Jenkins, and L. Vaughn.

27

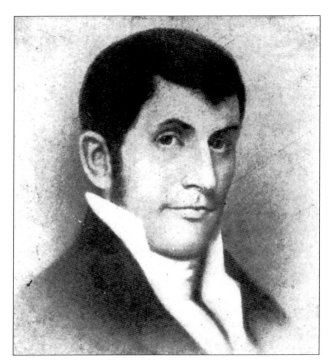

[ABRAM BLANDING, *c.* 1800]. Abram Blanding (1776–1839) was born in Massachusetts. After graduating from Brown University in 1797, he moved first to Columbia and then to Camden. In 1800 he passed the bar and was elected to the state legislature in 1806. Blanding was elected to the state board of public works in 1819, and in 1822 he became its chief superintendent, serving until 1827. He oversaw the construction of roads and the navigational canals of South Carolina, and promoted the Charleston, Louisville, and Cincinnati Railroad. This image is a Snyder Gallery's photograph of a painting.

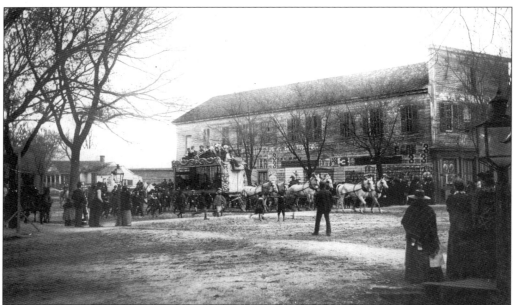

[CIRCUS PARADE, *c.* 1880s]. This Alexander image shows an early circus wagon drawn by six white horses arriving in Camden. A distant view of the old courthouse is seen on the left side. Later, the Wallace Circus visited Camden in the 1890s. On Circus Day, Kershaw families took the day off, enjoyed performances, had family reunions, and returned home that evening or the next day. Early streets were dirt and dark at night. In 1844, 20 gas streetlights were placed in the business district. In the 1890s and early 1900s, the city improved its street further by paving them in clay.

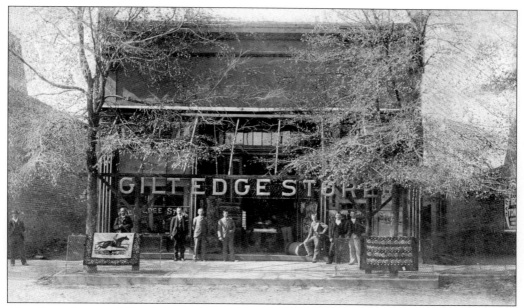

[GILT EDGE STORE, 1890s]. The 1890s view of the Gilt Edge Store (P.T. Villepigue's dry goods emporium) shows the early freestanding Broad Street store before the 1902 fire. After the fire their new brick building stood beside the Burns Hardware Store at 1023 Broad Street (west side). It advertised weekly in the *Camden Chronicle* using large advertisements starting in at least 1896. The store carried a full line of household goods including "gents' clothing from hats to shoes."

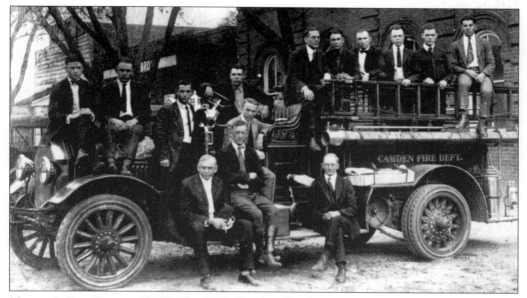

[CAMDEN'S FIRE ENGINE, 1920]. The 1920 Camden fire department members are pictured on a fire engine in front of the firehouse. They are, from left to right, H. Pearce (on the running board), B. Hornsby, D. Creed (seated), A. Rush, I. Owens, D. Goff, J. Cole, H. Carrison, H. Porter, P.R. Mayer, J. Zemp, B. Branham, D. McCaskill, and J. Reed. The brick firehouse was located at 533 Rutledge Street (south side) behind the opera house.

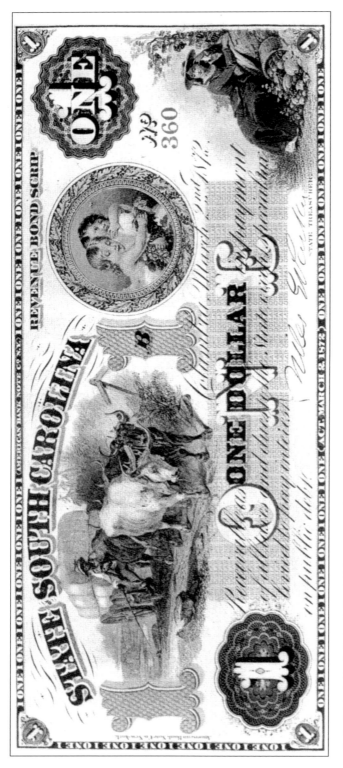

[STATE OF SOUTH CAROLINA, ONE DOLLAR NOTE, C. 1920s]. This postcard image documents the state of South Carolina's one-dollar revenue bond scrip issued in 1872 during the Reconstruction Period (1865–1877). The state's public printing cost for paper currency and other issues was $450,000 between 1872 and 1873. It was signed by state treasurer Niles G. Parker, and printed by the American Bank Note Company of New York. This example, which was reproduced for mailing and collecting, follows the postcard tradition of cards portraying stamps, coins, currency, flags, and national coats-of-arms. It was found in a Camden postcard collection.

[BANK BUILDING, c. 1906]. The Commercial National Bank, shown right, was located at 1025 Broad Street (west side). H.G. Carrison was its president. This building was built in the Beaux-Arts style. Moving north, the next bank on the west side was located at 1039 Broad Street; it later became the First National Bank with C.J. Shannon Jr. as president, and D.R. Williams as first vice-president.

[BURNS HARDWARE STORE, 1900]. James H. Burns (1870–1933) opened the Burns Hardware Store in Camden in 1900. In 1904, it became the Burns and Barrett Hardware store, which was at 1019–1021 Broad Street, on the south side of the First National Bank and next to the Gilt Edge Store. Burns constructed the building in 1898; the year the store opened to sell bicycles, pots, pans, and household goods and equipment. Clerks in that era worked from 7:00 a.m. until late at night.

[DeKalb Hotel, 1890s]. The three-story DeKalb Hotel was built in 1860 by the Camden Hotel Company at 548–550 DeKalb Street. Sanborn maps show it was known as the Hotel Workman from 1894 to 1905; it later became the Hotel Camden. The building was razed in 1914 and became the site of the new post office.

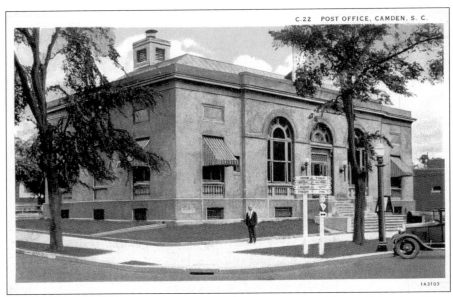

Post Office, [c. 1915]. This post office building opened on the old site of the Hotel Camden at 548–550 DeKalb Street (north side) in 1915. The Renaissance-style building was designed by Oscar Wenderoth, supervising architect of the United States Treasury Department, and erected by the Algernon Blair Construction Company of Montgomery, Alabama. In 1889 the post office was located at 20 Rutledge Street, and by 1900 it had moved to the 1000 block of Broad Street.

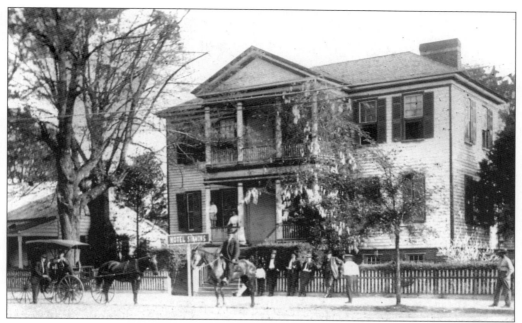

[HOTEL SIMMONS, 1890s]. As shown on the Sanborn Insurance Company's Camden maps, the two-story Hotel Simmons stood at 524 East DeKalb Street (north side) from 1889 to 1905. After that point it was listed as a livery until 1912. The site was several lots east of the DeKalb Hotel.

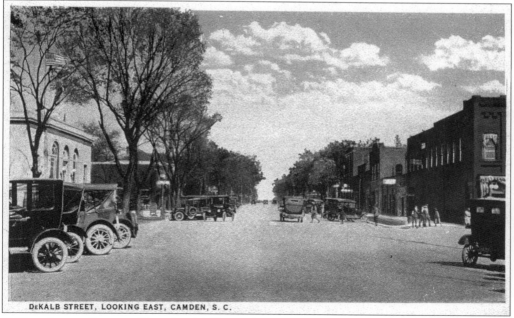

DEKALB STREET, LOOKING EAST, [c. 1920]. Looking east, this view of the south side of Dekalb Street shows the post office on the left. The earlier brick building that housed the Watkins Grocery has been rebuilt and enlarged, and the earlier frame structures that housed restaurants, tailors, cobblers, and the George T. Little livery stables have been replaced with brick buildings.

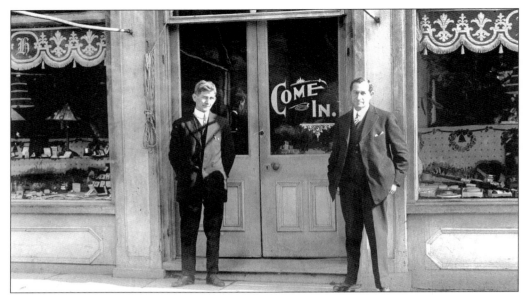

[HEYMAN'S JEWELERS, *c.* 1910]. A January 15, 1903 issue of the *Camden Chronicle* included a comment about the new jewelry store at 1026 Broad Street, which was established by Marion H. Heyman (1875–1955). It said, "One of the prettiest (if not the prettiest) business signs is that belonging to M.H. Heyman, the new jeweler." In 1914 Heyman was the vice president of the chamber of commerce. The postcard above shows Jerome M. Hoffer on the left and Mr. M.H. Heyman on the right.

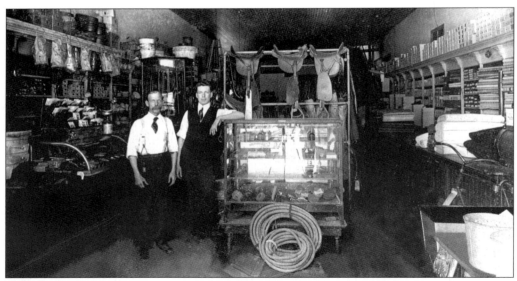

[SPRINGS AND SHANNON HARDWARE STORE, *c.* 1915]. This interior view shows the Springs and Shannon Hardware store that was located on Broad Street. The store's first building was destroyed in the great fire of 1902. Fortunately, it was rebuilt at 1007 Broad Street and continued to be one of Camden's leading stores. It advertised extensively in the *Camden Chronicle* from 1912 to 1923. It sold groceries, hardware, dry goods, shoes, harnesses, wire fencing, and other general merchandise.

[REV. HENRY WESTON CARDOZO, *c.* 1871].
Henry Weston Cardozo (1830–1886) was
born in Charleston, the eldest son of Lydia
Weston (*c.* 1805–1864), who was of African-
and Native-American ancestry, and Isaac
Nunez Cardozo (1792–1855), who
descended from a Sephardic (Jewish) family
of Portugal. Henry was elected to the South
Carolina state senate twice (1870–1874). He
was the auditor of Kershaw County from
1868 until 1869, and chairman of the
Kershaw County Republican party in 1870.
He became a minister in the Methodist
Episcopal church, as did his son Rev. Isaac
Nunez Cardozo (1856–1898).

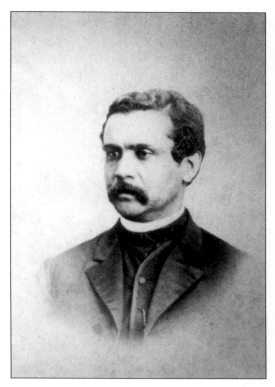

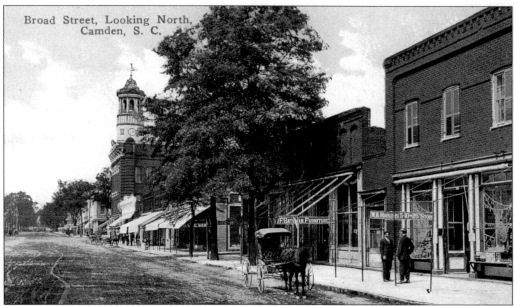

BROAD STREET LOOKING NORTH, [*c.* 1907]. This view shows the brick retail stores on the east side
of Broad Street, south of Arthur Lane. J.F. Bateman's furniture store is by the horse and buggy;
the two men are standing in front of W.A. Hinson's 5-10-25 store at 920–922 Broad Street. Broad
Street was finally paved in 1922.

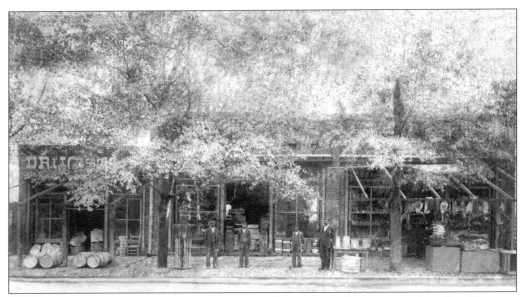

[DIBBLE STORE, c. 1892]. John Moreau Dibble (1848–1877) was born in Camden, the eldest son of Ellie Naudin and Andrew Dibble Sr. He purchased lot number 1043, on the east side of Broad Street, three lots south of Arthur Lane, in January 1873. John purchased 18 other lots in downtown Camden in 1875. After his early death, the business was owned and operated by his mother. In 1888, the store advertised "General Merchandise, Heavy and Fancy Groceries, Boots, Shoes, Hats." The store at 918 (1912 map) Broad Street was sold to Nettles & Stevenson in 1923, more than 50 years after the business was started.

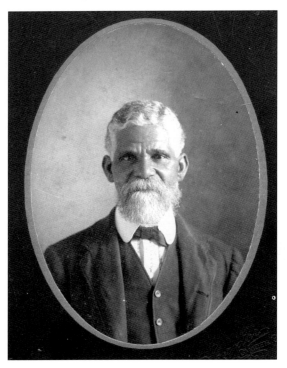

[ANDREW HENRY DIBBLE JR., c. 1880]. Andrew Henry Dibble Jr. (1850–1934) was the son of Andrew H. Dibble Sr. of Charleston and Ellie N. Dibble of Camden. Andrew H. Dibble Sr. was born in Charleston, the son of Andrew C. Dibble and Martha Smith, a free African American with Native-American heritage. Andrew Jr. married Elizabeth Levy (1856–1933) of Camden. His early career was in the general merchandise business in Camden, before moving to Sumter where he owned and operated his own general store.

[EUGENE HERIOT DIBBLE SR., *C.* 1890].
Eugene Heriot Dibble (1855–1934)
was the son of Ellie N. and Andrew H.
Dibble Sr. of Camden. In the early
1870s, Eugene attended Bridgewater
State College in Bridgewater,
Massachusetts and majored in
business. Eugene was certified to
teach in Kershaw County in 1874. He
represented Kershaw County in the
South Carolina State House of
Representatives from 1876 until 1878.
Eugene was an early businessman of
Camden and owned large parcels of
land. He gave more than 60 years of
service to his community.

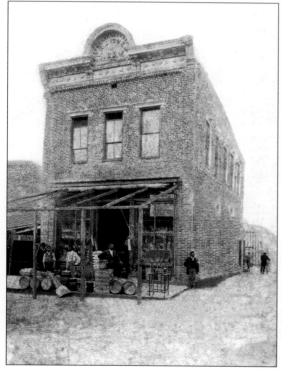

[EUGENE H. DIBBLE STORE, *C.* 1892]. In
1891, Eugene Heriot Dibble Sr. opened
his store on the corner of Broad and
DeKalb Streets. The 1880 Camden
business directory lists E.H. Dibble as
operating a grocery; by 1900 the
directory lists the business as "E. H
Dibble & Brother Grocers and Crockery."
The view above shows, from left to right,
W.S. Dibble, R. Lambert, R.D. Dibble,
E.H. Dibble, G. Cant, and Rev. J.B. Taylor
with a bike. The structure at 1053 Broad
Street still stands in the heart of
downtown Camden.

37

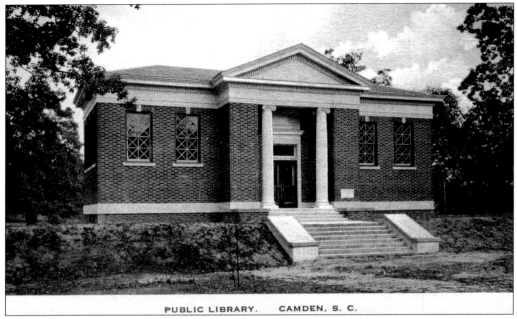

PUBLIC LIBRARY. CAMDEN, S. C.

PUBLIC LIBRARY, [1915]. In 1915, the Carnegie Foundation paid $5,000 for the construction of Camden's public library on Monument Square at 1314 Broad Street. The library had 4,000 volumes in 1926. The structure had a new section built in 1963, but a new public library was built in 1973. Beginning that year, the Camden Archives and Museum were housed in the first structure.

I am on my way to meet you and hope you can arrange to call at
L. J. WHITAKER'S STORE

JULY 23rd & 24th, 1913.
P. S.—They call me Miss Traymore.

TRAYMORE TAILORING CO.

[L. J. WHITAKER'S STORE, c. 1913]. This advertising card made by the Rochester Photo Press for the Traymore Tailoring Company of New York shows a very sophisticated image of a beautiful young lady with flowers, and it was to be used for a national sales promotion. The card indicated that a Traymore representative would demonstrate their products at the L.J. Whitaker (1882–1965) Tailor Shop at 953 Broad Street during a visit on July 23 and 24, 1913.

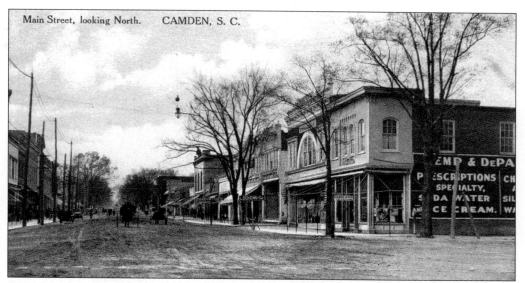

MAIN STREET LOOKING NORTH, [c. 1910]. This scene begins with the northeast side of Broad Street from Rutledge Street and shows Zemp and DePass Drug Store (1002) on the right side. Dr. F.L. Zemp (1819–1893) was of Swiss origin, attended the South Carolina Medical College and the Medical College in Philadelphia, and graduated as a physician and pharmacist professional. He moved to Camden, ran a successful drug store and office practice, and owned several other businesses.

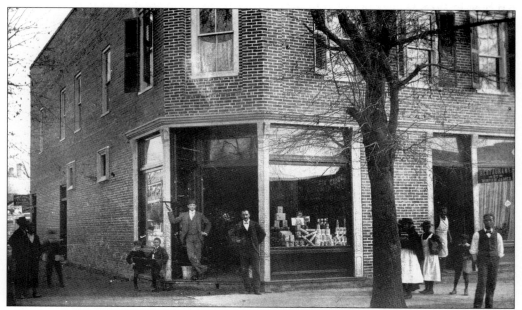

[WATKINS GROCERY STORE, c. 1899]. The E.F. Watkins (1861–1909) grocery store (above) was located at 1052 Broad Street. This corner store shared a space with Wintaw James's restaurant, which was on the south side section at 1050 Broad Street. An angle-corner entrance to a retail store space is distinctive. According to the Sanborn Insurance Company's Camden maps, the grocery store was at that location from 1900 until 1923.

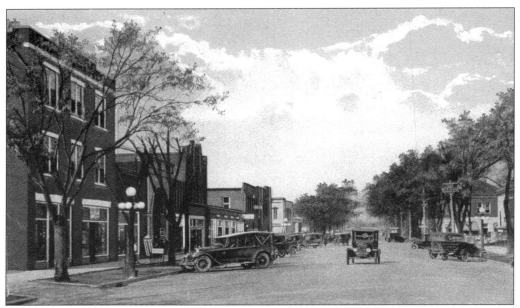

DeKalb Street, Looking West, [c. 1916]. This postcard shows the south side of East DeKalb Street. George T. Little's livery stable had been razed. New buildings included a different 3-story brick Camden Hotel (521–525) and the Majestic Movie House (527), owned by T. Lee Little. Smaller buildings housed a pressing shop, drug store, and restaurants (as documented in a 1925 Sanborn fire map).

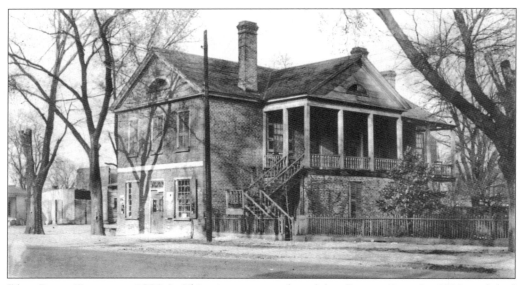

[The Price House, c. 1920s]. This site was purchased by George Rout in 1802 and had improvements made when it was sold in 1825. The present building existed when the 724 Broad Street site was sold in 1838 and the ground level was used as a tavern. This structure is the oldest home and business combination still standing in Camden. Richard and Florence Price operated their grocery store here starting in the early part of the 20th century. Then Dr. E.L. Price Jr. (pharmacist) owned the house until 1961.

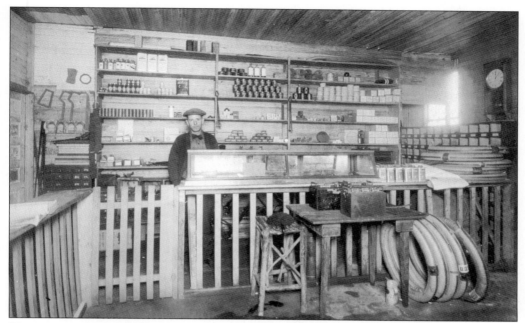

[BEARD'S BIKE SHOP, 1914]. The H.E. Beard and W.J. Hasty bicycle shop was located at 921 Broad Street and was listed in the 1914 Camden city directory. Bicycle and automotive repair services were offered, as well as related supplies. They vulcanized the tubes in the tires for both bikes and automobiles. S.B. Beard also had an automobile accessories shop next door.

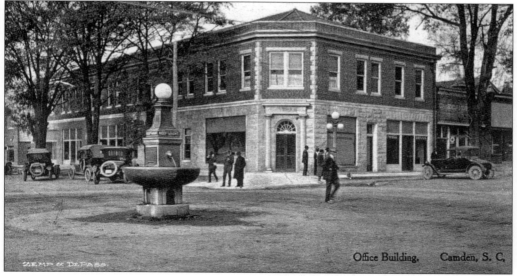

OFFICE BUILDING, [c. 1916]. The Savage & Crocker office building (1916) stands on the northwest corner of DeKalb and Broad Streets opposite the post office. This postcard view looks west down DeKalb Street with street numbers beginning at 138. The Loan and Savings Bank at 1101 Broad Street, which was established in 1911 with L.L. Clyburn as president, had the corner office. At that time the Richard Kirkland Memorial Fountain was still at the junction of Broad and DeKalb Streets.

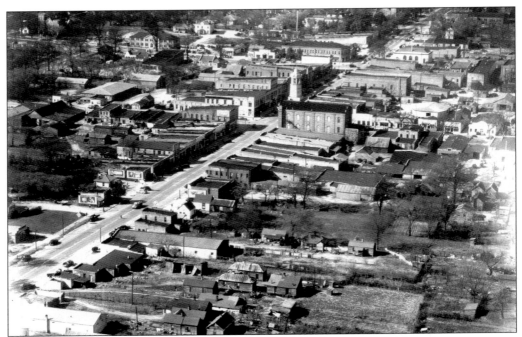

[AERIAL VIEW OF CAMDEN, C. 1930s]. This southeast aerial view shows Broad Street, beginning in the lower left corner near York Street and extending diagonally towards the upper right corner past DeKalb Street. The opera house's white tower in the upper center and the post office on Dekalb Street are both easily located.

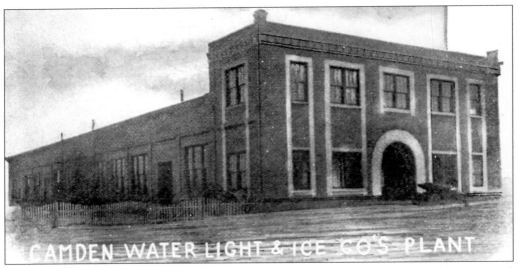

[WATER, LIGHT AND ICE COMPANY'S PLANT, C. 1910]. The first water plant was built in 1897 and was located south of DeKalb Street near the railroad tracks. The plant was destroyed in a 1902 fire, which left the city without water and lights for a year. In 1907 it was destroyed again when a boiler exploded. The light and power plant at 105 DeKalb Street used a 320-kilowatt generator that ran on fuel oil. Block ice was manufactured in its Mill Street plant and made from filtered water. The building stands vacant in 2002.

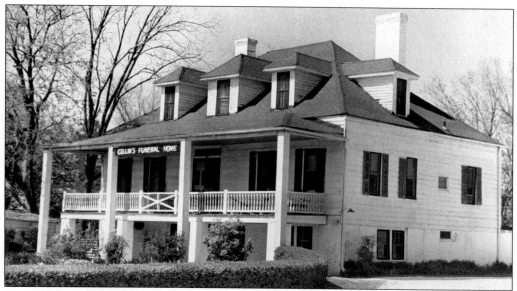

[COLLINS FUNERAL HOME, C. 1930]. The 1823 house above was built by Phineas Thornton, who arrived in Camden prior to 1800. Evans Collins (1853–1919) was the son of John Collins. He married Elizabeth Dunlap (1853–1927), daughter of Charlotte Gandy and Elias Dunlap. Elizabeth purchased the home at 714 DeKalb Street in 1889. Evans operated a livery stable at this location prior to the establishment of the funeral business. In 1914, their son Amon R. (1882–1962) started the funeral business in a small building facing Campbell Street, which was razed in the 1950s when it moved to 714 DeKalb Street.

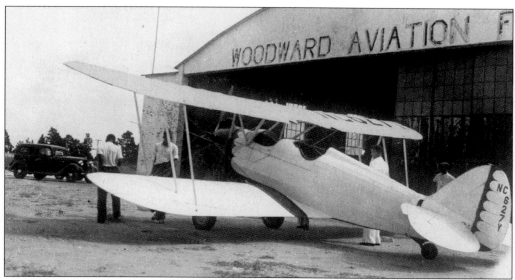

[WOODWARD AVIATION, 1929]. In 1929, the Camden airport was established on land contributed by Ernest Woodward (1882–1948) at a cost of $30,000. The airport is located north of Camden between U.S. Route 1 and Red Fox Road. Biplanes were flown from the Charlotte airport for the grand opening ceremonies. The aerial photograph of Camden on page 42 was taken from an airplane using this port. (Further information, see Kershaw County Volume 7, pages 48 and 49.)

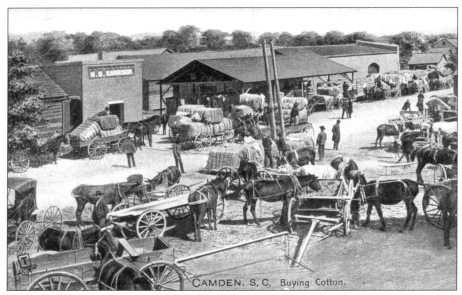

BUYING COTTON, [c. 1900]. This 1907 postcard scene shows the local farmers hauling their bales of cotton to J.B. Steadman's cotton platform located at Arthur Lane, a dirt alley that diagonally passes through the center of the picture above. The site is behind the southeast side of Broad and Rutledge Streets. The roofed cotton platform has been razed, while the brick H.G. Carrison building and brick warehouse behind the platform still stand, though somewhat altered. The area with the wagons below the narrow alley was filled with a row of buildings during the 1940s.

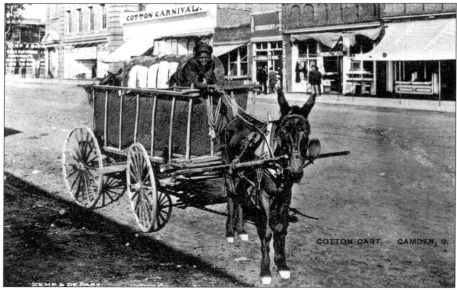

COTTON CART, [c. 1907]. This postcard picture shows a boy holding the reins of their family's mule and wagon. The cotton harvest in the cart was their major source of income for that year. The wagon pauses on Broad Street while the father stops at one of the stores. In the background is the Cotton Carnival at 944–946 Broad Street, which was H.L. Schlosburg's dry goods and clothing store.

SEABOARD RAILWAY STATION, [C. 1937]. Costing $50,000, the new Seaboard Railway Station opened for travel on November 18, 1937. This modern station was built so that it could better serve the transportation needs of the traveling public. It is still located on West DeKalb Street and the "Silver Star" serves Camden daily. (Further information, see Kershaw County #7, page 49.)

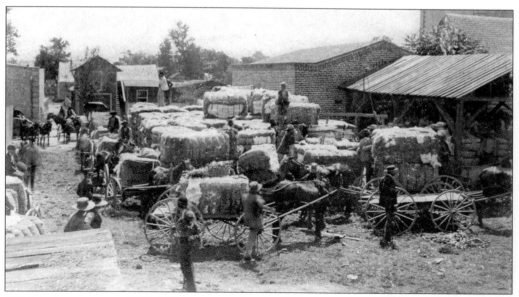

[COTTON PLATFORM, C. 1880s]. This image, taken by W.S. Alexander, shows Camden's Steadman Cotton Platform during the late 1880s, which was located behind the east side of Broad Street. The frame structures in this open area are gone and have been replaced by several storage buildings of various sizes and ages. In the upper right is the back of the opera house that was built in 1886 at the corner of Broad and Rutledge Streets.

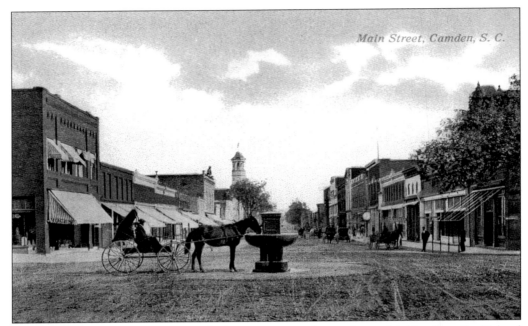

Main Street, Camden, S. C.

MAIN STREET, [*c.* 1911]. Looking south, this street scene shows a horse drinking from the Richard Kirkland Memorial Fountain, which stood at the intersection of Broad and DeKalb Streets. Kirkland, a Confederate soldier, was called the "Angel of Marye's Heights" for his compassionate aid to wounded soldiers in the Civil War. The pennies of Kershaw children and a donation of $1,000 from the National Humane Alliance of New York financed this fountain, which was dedicated in 1911. (Further information, see Kershaw County, volume 7, page 38.)

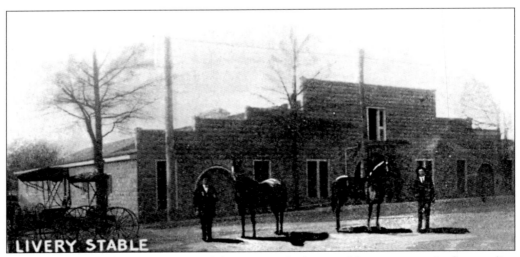

LIVERY STABLE

LIVERY STABLE, [*c.* 1908]. At the turn of the century, the livery stable was a necessity for traveling salespersons and others who needed a horse and buggy for business or social trips some distance away. G.T. Little at 529 East DeKalb Street was one of the largest livery stables in Camden at that time. Other stables were owned by S.B. Latham, G. Huggins, and F. Collins.

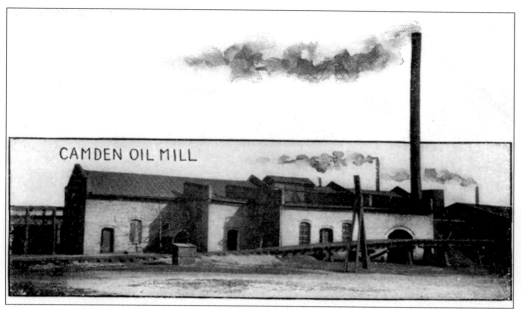

CAMDEN OIL MILL, [c. 1908]. The Camden Oil Mill (cotton seed oil company) was built in 1902 with a capital of $90,000. It consisted of an oil mill and gin, which were located 106 DeKalb Street by the tracks of the Southern and Northwestern Railroad. Its capacity was 60 tons of cottonseed per day and it employed 57 people. W.R. Eve was the local manager. The mill ginned about 2,500 bales of cotton annually and turned out crude oil, meal, hulls, and linters.

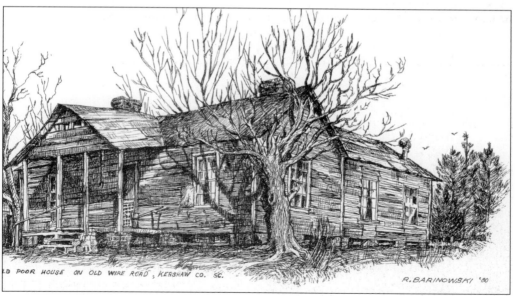

[KERSHAW COUNTY POOR HOUSE, 1980]. In the early years of this country the problem of destitute citizens, especially those without supportive family members who could care for them, caused local governments to build homes for those who could not work, house, or feed themselves. The Kershaw County poor house was built near the northwest corner of Logan and Stagecoach Roads at the turn of the century. The drawing above was made by R. Barinowski in 1980.

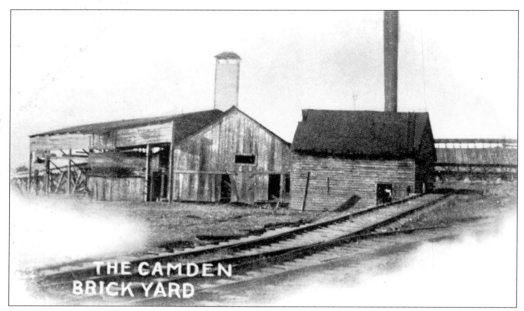

CAMDEN BRICK YARD, [c. 1908]. The Camden Brick Yard was one of the largest brick companies in the Southeast and was owned and operated by C.A. Guignard of Columbia. It had a capacity of 36,000 bricks per day. The yard was south of Market and Mulberry Streets and was marked on a 1912 map.

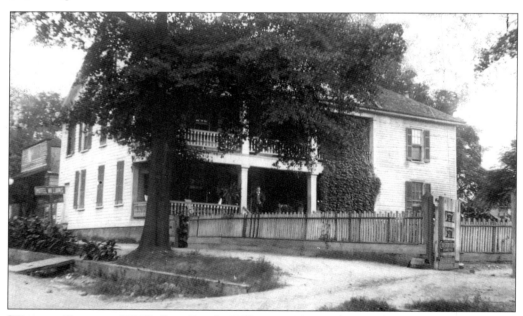

[WILLIAMS HOTEL, c. 1905]. Ross Brooks Williams (1857–1924) was elected sheriff and served from 1892 to 1900. From that time on, he owned the Williams Hotel (pictured above) at 1126 Broad Street and the City Grocery (later Broad Street Lunch) at 1128 Broad Street, which is seen at the left behind the boarding house. These east side buildings were across from the courthouse. Those with business at the courthouse often went to this grocery for a fast sandwich and drink.

48

Two

CULTURE

By 1900, the Baptist, Episcopal, Methodist, and Presbyterian Churches had well-established congregations. The public school system was still in the evolutionary stage and the opera house was attracting touring stage events and presenting local performances. The photography of William Alexander and others documented people, places, and events of that era. Historical pageants like "Camden, Yesterday and Today" became popular. The influx of Northern financiers and industrialists that wintered in Camden added yet another layer of culture and expanded the sports scene and equestrian activities. Camden's professional and cultural structures grew from the foundations taught by its churches and schools, which served an expanded population of 2,441 in 1900.

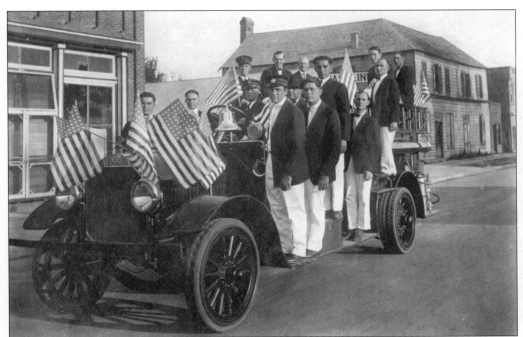

[FLAG MEN, FIRE ENGINE, C. 1918]. This patriotic picture suggests that Camden's fire engine was part of a Fourth of July parade or an event related to World War I. The firemen included Chris Beleos, Dewey Creed, Seep Sheheen, Nim and Robin Zemp, and two members of the Mayer family.

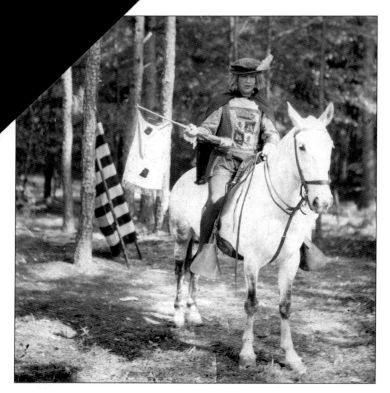

[HERALD, MAY DAY FESTIVAL, 1925]. On May 1, over 3,000 people visited the Kirkwood Hotel to witness the historical pageant entitled "Camden, Yesterday and Today." The entire meadow served as the stage for the historical skits, which included presentations portraying the Wateree River Native Americans, the Colonial era, etc. This view shows herald Rob Kennedy announcing the next skit.

[DANCERS, MAY DAY FESTIVAL, 1925]. Mrs. Donald Morrison directed this community endeavor, which performed 11 skits with horses, wagons, and a multitude of children and adults in period costumes. Joby Mills, left, and Miss Dolly Singleton, right, shown here in their costumes, danced several minuets. (Photographed by J.A. Sargeant.)

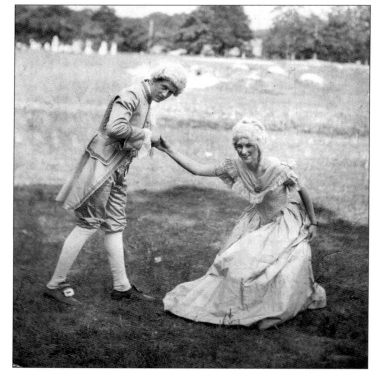

MARCH 19-25 1933.

Camden's Bi-Centennial, 1933. Camden's bicentennial, which took place in 1933, began on Sunday, March 19th and continued through Sunday, March 26th. The events included a polo game on the first Sunday, the 23rd annual horse show on Tuesday and Wednesday, and the fourth annual Carolina Cup race on Saturday. Golf tournaments ran the entire week, and street dances and balls were held on each evening.

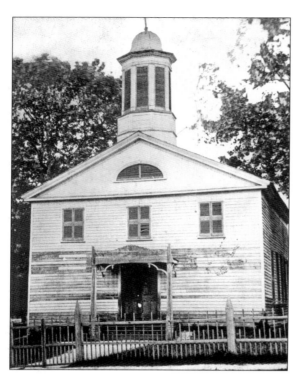

[BAPTIST CHURCH'S SECOND SANCTUARY, *c.* 1880]. The first Baptist service in Camden (*c.* 1775) was given outdoors by the Rev. Richard Furman Sr. This was because the sheriff refused the use of the courthouse, since a 1706 British legal declaration stated that ministers of other denominations were debarred from performing marriage, baptisms, and funeral services. Reverend Furman returned in 1784 and gave another service that converted a small membership. This first meetinghouse (1809) was used until the second edifice (1836), shown left, was built at 1111 Broad Street. It was remodeled in 1889 and used until the 1908 sanctuary was erected.

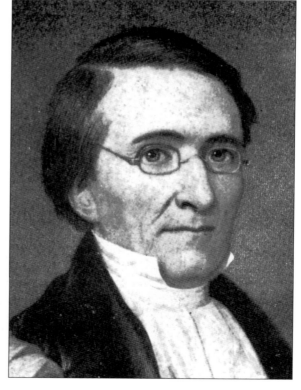

[BISHOP THOMAS DAVIS, *c.* 1850]. Thomas F. Davis (1804–1871) was born near Wilmington, North Carolina and graduated from the University of North Carolina in 1822. He became a minister in 1832. Davis came to Camden's Grace Episcopal Church in 1846 and was elevated to the rank of Bishop of South Carolina in 1853.

[Rev. A.T. Jamison, 1894–1900]. The first Baptist structure was built in 1809 at the northwest corner of Market and York Streets. Rev. S. Brantley, principal of the Camden Orphan Society School, officiated at the church dedication. The first pastor was J.B. Cook. The Baptist congregation began with 25 members in 1810, but a revival in 1832 increased the membership to 100. Rev. A.T. Jamison (1894–1900) was the minister in 1900. When he left, he became the superintendent of the Connie Maxwell Orphanage in Greenwood.

[Episcopal Church, c. 1900]. In 1757, Camden was a part of the large inland St. Mark's Parish. Rev. Charles Woodmason of Charleston served the settlement from 1766 until 1772. During the Revolution and for some time afterwards, the Church of England was regarded with suspicion as an imperial institution with an intolerable past. In 1808, Anglican parishioners reorganized under the new name Episcopal, keeping similar rites and rituals. Grace Episcopal Church, below, was erected in 1873.

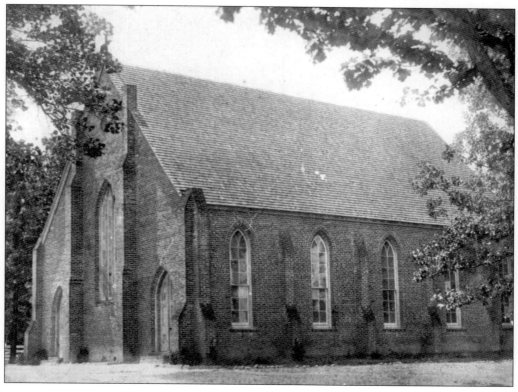

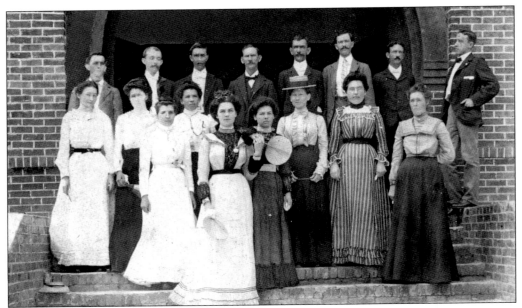

[CAMDEN TEACHERS, 1900]. Robert M. Kennedy (1866–1948) was the superintendent from 1893 to 1912. Camden's population was 2,441 in 1900. Camden's white school district had one private and two public schools, 10 teachers, and 471 students in a 10-grade program that lasted 36 weeks a session. In 1900 the two male teachers earned $720; eight female teachers earned only $287, each.

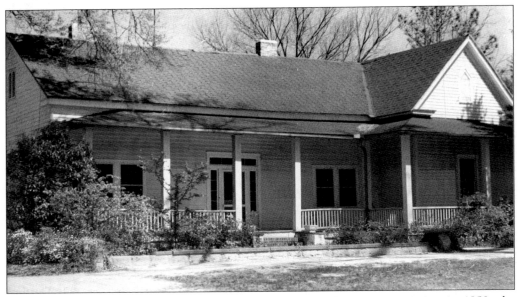

[THE McCANDLESS SCHOOLHOUSE, c. 1930s]. Built by the education association in 1850, the McCandless school was located in a frame building on Laurens Street. In 1893, this building was deeded to the trustees of the Camden graded schools. Later, the schoolhouse was sold and moved to a new site at 410 Laurens Street, where it became a residence. The brick graded school was built on the initial site.

[MRS. McCANDLESS, TEACHER, 1850]. Mr. Leslie McCandless (1820–1898) graduated from South Carolina College in 1838 and began his Camden private school teaching career at the male academy in 1839. Miss Fanny A. Coleman (1823–1889) began teaching the girls at the female academy *c.* 1845. She became Mrs. McCandless in 1848, and both McCandlesses taught in Camden until the Civil War. During one period, Mrs. McCandless taught seven pupils for a tuition of $300 each, not including board.

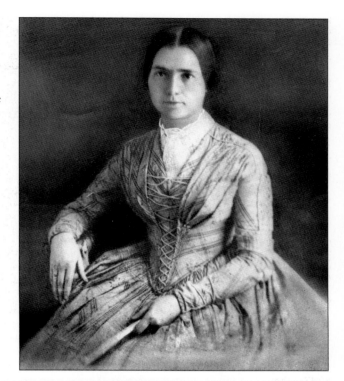

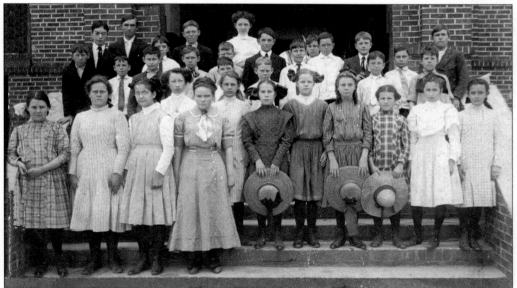

[SIXTH GRADE CLASS, *c.* 1910]. C.L. Legge was superintendent and R.F. Simpson was principal of the high school from 1913 to 1914. M. Burnett (rear center) and her sixth grade class are shown above. Other graded school teachers were N.B. Hough, L. Shannon, S. Parrish, S. Taylor, A. Phelps, and A. Workman. The class's 36-week fall schedule lasted from September 15 to December 22 (70 days), and the spring term began on January 5 and lasted until June 9 (100 days). The county had only one high school.

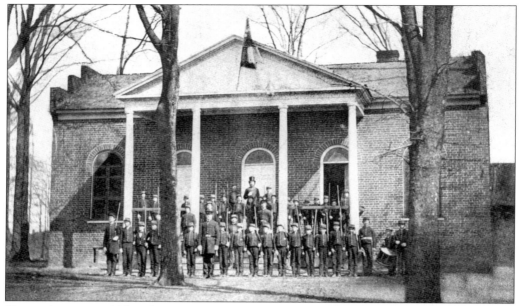

[BRICK ACADEMY, 1854]. The Camden Orphan Society was incorporated in 1788. Its school opened in 1791 with Robert Dow acting as the first principal. Other students paid a tuition fee. Rev. J. McEwen taught the school from 1819 until 1823. In 1820, two brick academy buildings, one for each gender, were built on adjacent lots east of the Presbyterian Church on DeKalb Street; they were finished in 1822. Mr. McCandless rented one in 1854 and Mr. Peck's Academy (shown above) was there from 1859 until 1863. In 1893, the eastern building was razed and the other one was sold and remodeled as a home. It no longer stands.

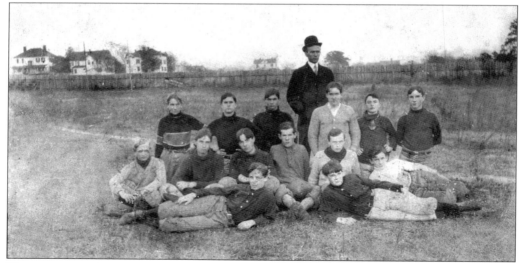

[FOOTBALL TEAM, CAMDEN HIGH SCHOOL, 1908]. The 1908 football game was the first after a three-year hiatus. It was played on November 6, 1908 against Winnsboro High School at the baseball park. The score was 0 to 0. Camden High School's curriculum for grades eight to eleven included English, math, science, history, Latin, mythology (grades eight and nine), and electives studies; business courses and French were taught in the eleventh grade.

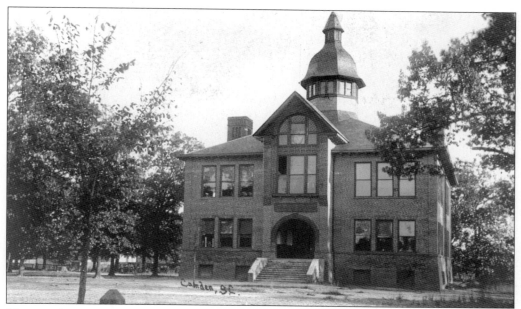

[GRADED SCHOOL, c. 1907]. The $11,000 8-room brick Graded School on Laurens Street was dedicated on March 14, 1894 at the site of the old McCandless School. The city schools were free for residents; however, others paid a monthly fee of $1 for primary grades one through three; $1.50 for grammar grades four through seven; and $2 for first through fourth year of high school.

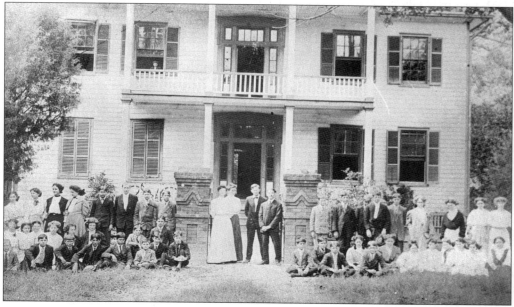

[LEITNER HOUSE, HIGH SCHOOL, c. 1909]. This house was built by John M. Gamewell c. 1860s and later became the home of Maj. Zack Leitner (1830–1888). In 1903, Zack Leitner's house and four acres on Monument Square were bought for $5,000 and used as the high school until it was sold in 1920. After the Reynolds House fire of 1921, the grammar students went to the graded school building from 8:30 to 1:00 a.m., and the high school students attended from 1:00 to 5:30 p.m.

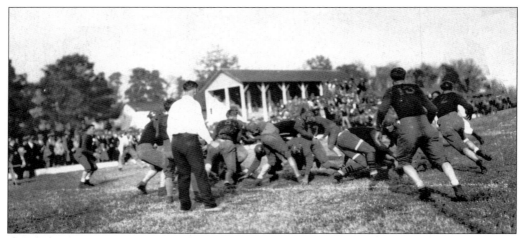

[FOOTBALL TEAM, 1912]. The 1912 football team played Mt. Zion in Winnsboro, and high schools in Sumter, Bishopville, Lancaster, and Lexington. R.M. Kennedy was the principal for the grammar and high schools in 1912. The grammar school teachers were M. Burnett, first grade; A. Workman, second grade; L. Shannon, third grade; G.E. Taylor, fourth grade; A. Phelps, fifth grade; M. Burnett, sixth grade; and H.O. Strohecker, seventh grade and superintendent of the grammar school. The high school curriculum lasted for two years. The teachers were E. Zemp, first year, and A. Corbett, second year.

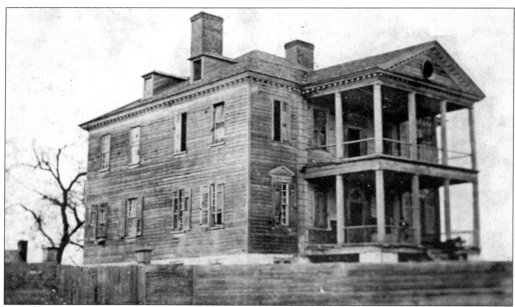

[KERSHAW/CORNWALLIS HOUSE, C. 1858]. This three-story colonial Georgian mansion was begun in 1777 by Joseph Kershaw, the town's wealthiest entrepreneur. The almost finished house was seized by Lord C. Cornwallis and made into the British headquarters from 1780 to 1781. After the Revolution, Kershaw returned and died in the house in 1791. It was sold in 1805 to the Camden Orphan Society for $1,500 and was a school until 1822. Later, it became a Confederate storehouse and was finally destroyed in 1865. A reconstruction of it was erected in 1977 at the Historic Camden Revolutionary War Site.

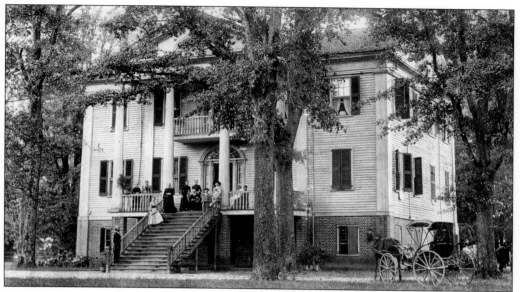

[REYNOLDS HOUSE, c. 1880s]. The George Reynolds (1803–1847) mansion (c. 1834) was a 3-story, 16-room house on a lot bordered by Lyttleton, Laurens, and Fair Streets. The Camden School District wanted to use this home as its next high school building and acquired it for $20,000 in the fall of 1920 when there were 93 high school students and 420 grammar students. Unfortunately, the house was destroyed by fire on Jan. 1, 1921. After the fire, the Graded School building was used by both grammar and high school students. The 1922 Grammar School was built on this lot. This is probably an Alexander photograph.

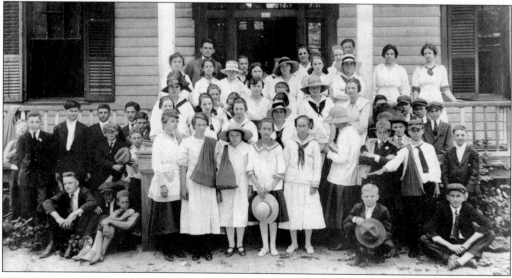

[EIGHTH GRADE CLASS, 1917]. During the 1913–1914 school year, Camden students' curriculum in grades one through seven included reading, spelling, writing, language, history, music, and drawing. Nature studies were offered in the first through the third grades; geography in grades two through seven; science in the fourth through the seventh grades; and physiology in the seventh grade only. The class picture is taken in front of the Leitner House.

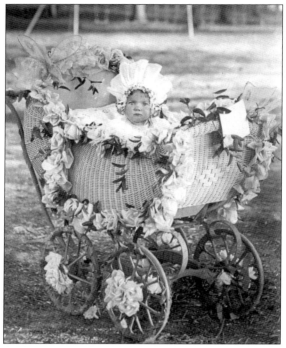

[BABY BUGGY PRIZE WINNER, c. 1922]. At the turn of the century, popular competitions such as decorating the prettiest baby buggy were sponsored by various groups. One of the goals was to encourage young mothers to come to meetings, where the "focus" was to distribute information on ways to decorate baby carriages but the sponsors could also distribute information on ways to care for babies.

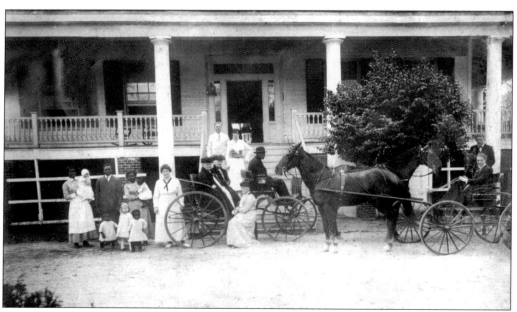

[BLOOMSBURY, c. 1915]. Bloomsbury (c. 1850s) at 1707 Lyttleton Street was built by Col. James Chesnut (1773–1866) as an in-town summer home away from the malaria of the swamps. The home has an above-ground brick basement, which, along with the first floor, was designed with two rooms and a central hall. Chesnut was elected to the state legislature in 1802, 1804, and 1808, was Camden's Intendant from 1806 to 1807, and was elected to the state senate in 1832. His son was Gen. James Chesnut, C.S.A.

[DR. JOHN W. CORBETT, *c.* 1890]. Dr. John W. Corbett (1863–1953) was born in Cheraw, graduated from the Medical College of Charleston, and studied at John Hopkins Hospital in Baltimore. By 1890 Corbett was mayor of Camden, and he established the town's first infirmary (*c.* 1900) with a few beds on Laurens Street. Later, Corbett was the vice president of the Camden Hospital (1913) and became president in 1926. He was a doctor for 55 years.

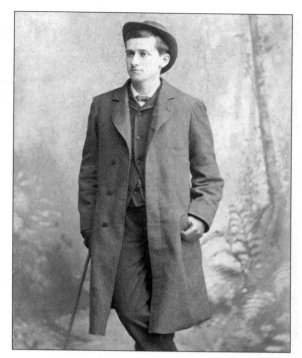

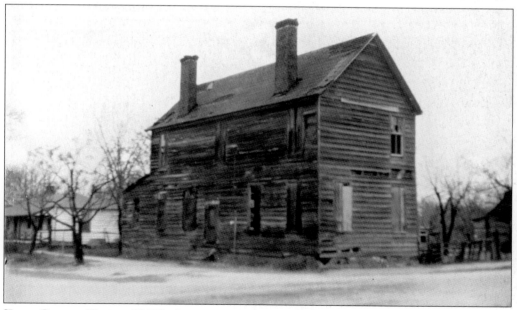

[ISAAC DUBOSE HOUSE, 1910]. Capt. Isaac Dubose (1754–1816) moved to Camden after the Revolution and was an active political figure. He was sent to the Constitutional Convention in 1790, was the intendant of Camden in 1792, and was elected to the legislature in 1796, 1799, and 1806. His home on the corner of King and Market Streets (built *c.* 1790s) reflected the simple functional residence of a person of significance without the trimmings of the wealthy. It became a vacant, deteriorated structure by 1900 and was eventually razed.

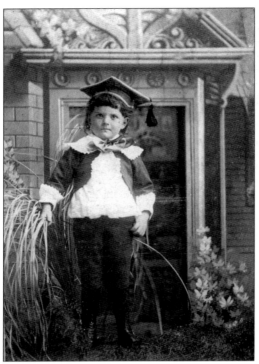

[PORTRAIT OF A BOY, c. 1880s]. This is photographic studio portrait of William Alexander's nephew, Thomas Wilson (1883–1889), the son of George Gilman Alexander (1846–1913). Here he is standing in front of the same backdrop scene as William used in his self-portrait on page 64. Thomas is stylishly dressed, wears a mortarboard cap, and holds pieces of chair cane. Thomas died in childhood.

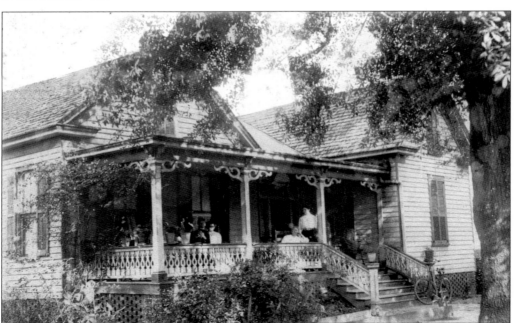

[ROSE COTTAGE, c. 1907]. The Rose Cottage (built c. 1831) at 618 Laurens Street was built by I.B. Alexander (1812–1884) as a schoolhouse for their children. This cottage is separated from Alexander's Tanglewood home by a garden lot. Members of George G. Alexander's (1843–1913) family are standing on the porch. The house still stands.

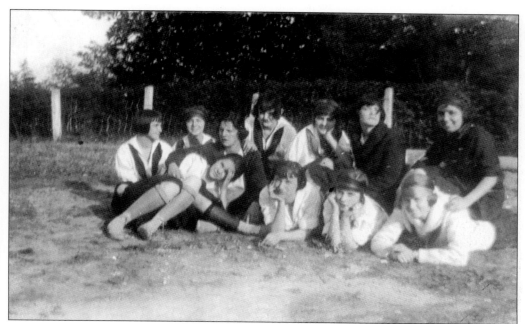

[GIRLS BASKETBALL TEAM, 1922]. This picture shows members of the 1922 girls basketball team at Camden High School. They played similar city high school teams from Columbia, Lancaster, Bishopville, and Sumter.

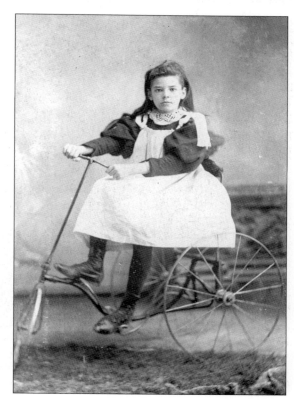

[ANNIE ALEXANDER, c. 1880s]. Alexander included a c. 1880 tricycle as a studio prop in this photographic portrait of his oldest daughter Annie Douglas (1889–1916). Here, Annie is wearing a dark blouse with puffed sleeves, a decorative lace collar, and a skirt.

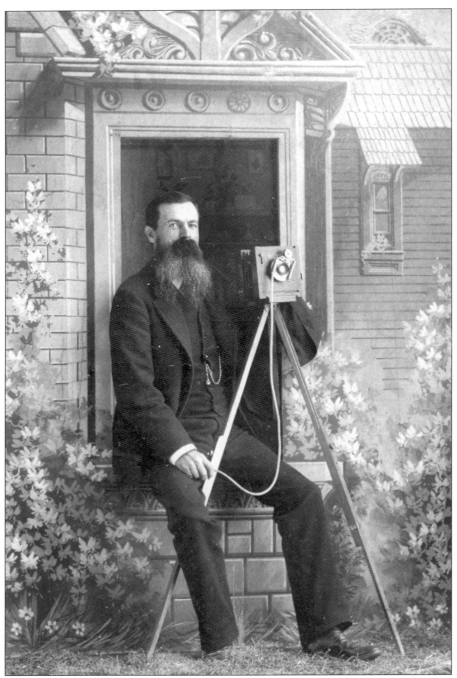

[WILLIAM STACY ALEXANDER, C. 1880]. William Stacy Alexander's (1856–1891) handsome studio self-portrait is shown above. William's father, Isaac B. Alexander, was an excellent daguerreotypist and taught William the art of photography. Selected examples of William's images are included in this volume. He opened a photographic studio in 1876 and operated it for 15 years on the DeKalb Street lot behind Dibbles's corner store.

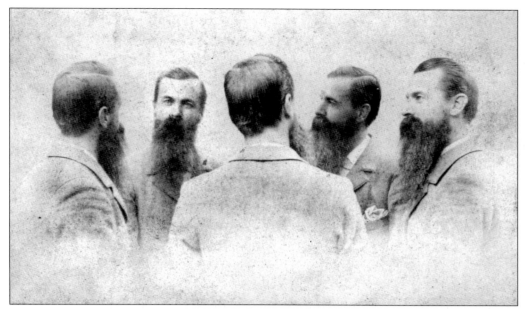

[HEAD STUDIES, W.S. ALEXANDER, 1880s]. In the 1880s, the photographic novelty of printing five different head views on a postcard was popular. The person sat in a chair and looked in one direction while the chair was rotated to face various positions with a negative exposure taken at each stop. This was how the side-by-side images of William Alexander's head were created.

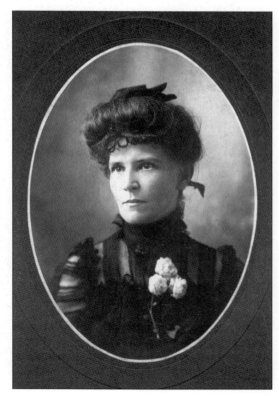

[MRS. W.S. [LUELLA] ALEXANDER, 1880s]. William Alexander's portrait of his wife Luella Anderson (1860–1932) was likely taken after his Camden studio was opened in the late 1870s. Luella was wearing a stylish dress of that era, and the image was placed in the popular oval format. It is thought that Luella continued producing photographs at the Alexander studio after William's death.

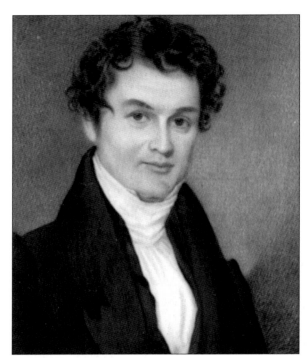

[SELF PORTRAIT, ISAAC BROWNFIELD ALEXANDER, 1835]. Dr. Isaac V. Alexander (1749–1812) graduated from Princeton University in 1772 and lived in Camden by 1780. He attended to Gen. Baron DeKalb when he was mortally wounded in the Battle of Camden. His son, Isaac Brownfield Alexander (1812–1885), studied jewelry in New York, developed skills in painting miniatures on ivory, and became a pioneer daguerreotypist beginning in 1841. Isaac Brownfield's Camden commercial trade included jewelry, silversmithing, gunsmithing, and painting. He also painted the secessionist banner in 1860. This miniature self-portrait on ivory was painted in New York in 1835.

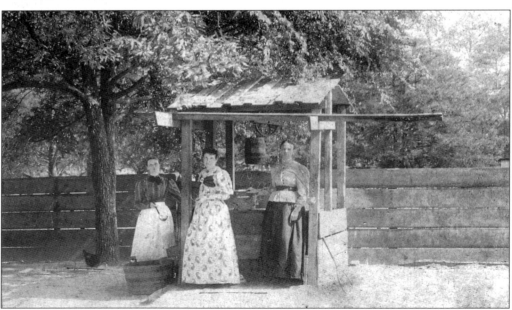

[WOMEN AT THE WELL, C. 1880S]. In 1884, public wells were located at strategic locations such as 228 and 300 Broad Street, as shown on a Sanborn map of 1884. Later, maps had wells at 214, 218, and 261 Broad Street. The above 1880s Alexander image shows a roofed well structure that was placed beside the road in front of a private fence. Three ladies are at the well with their buckets to carry water back to their homes. A public water system with piped water was installed in 1897.

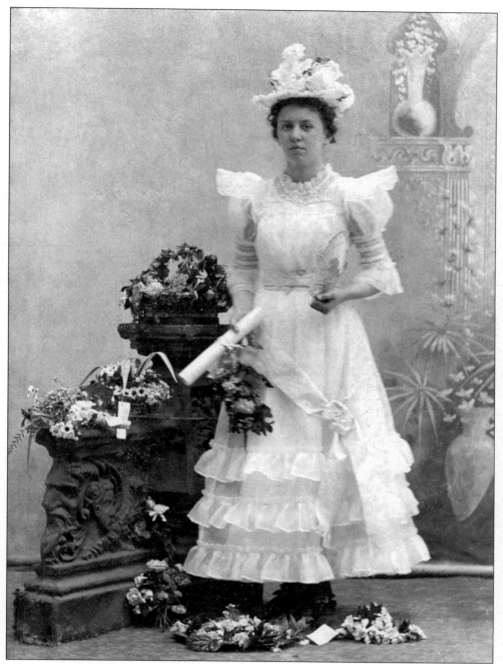

[ELIZABETH M. ALEXANDER, C. 1900]. Elizabeth M. Alexander (1882–1969) married Robert Guy Zetrouer. She was the daughter of George G. Alexander and a niece of William. This photograph may have been taken by Mrs. (W.S.) Luella Alexander at the Alexander studio. Elizabeth is shown in her elegant graduation dress and holds her diploma in her right hand. One of the two dressmakers in Camden likely made this dress, since fashionable ready-made clothing for women was not available.

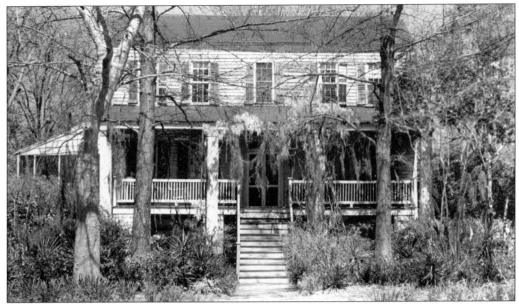

[TANGLEWOOD, ALEXANDER'S HOME, *C.* 1940s]. In 1827, Mrs. Ann Hutchins K. Gilman bought six lots on the northwest corner of Laurens and Broad Streets at Monument Square, in an area once called "Logtown" during Colonial days. She built this classic two-story Carolina farmhouse in 1831 as a wedding present for her daughter Elizabeth M. Gilman, who married Isaac B. Alexander. The photographer William S. Alexander was born there, and it eventually became the home of George G. Alexander.

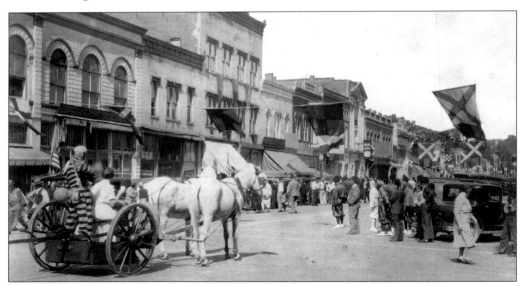

[SHRINER'S PARADE, *C.* 1912]. The Scottish Rite of Freemasonry migrated from Europe to Jamaica and then to Charleston in 1801. Appendant groups such as the Knights Templar or Shriners are known by the public for their colorful costumes, parades, health programs, hospitals, and charitable works. The parade above includes initiates in costumes riding in a horse-cart up Broad Street.

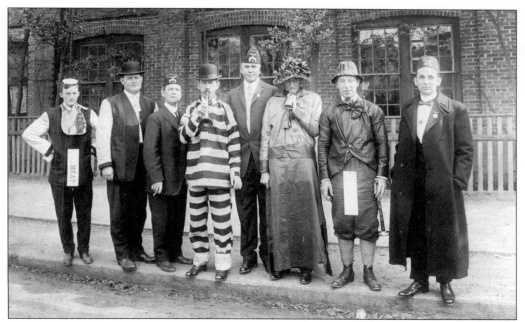

[MASONIC INITIATION ACTIVITY, *c.* 1912]. The Masonic initiation involved dressing inductees in incongruous garments, such as prison uniforms or ladies' dresses. The men, from left to right, are Mr. Murray, unidentified, N. Roland Goodale, Robert Goodale, "Bee" Pierce, Reverend Rowan, Bill Young, and W. Robin Zemp. Later, they would ride in a parade up Broad Street.

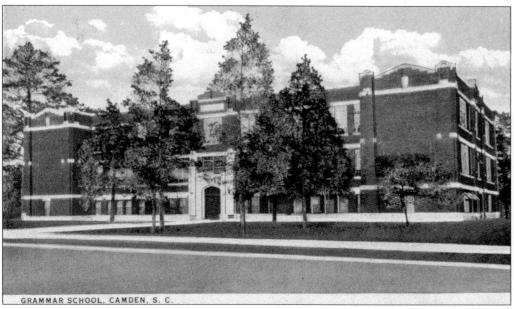

GRAMMAR SCHOOL, CAMDEN, S. C.

GRAMMAR SCHOOL, [*c.* 1922]. In 1922, the 3-story Grammar School was built at a cost of $125,000 on the Reynolds lot at the corner of Lyttleton and Laurens Streets. This postcard view was one of a series that pictured schools, churches, sites, and scenes of the 1920s. The school had 21 classrooms, an auditorium, and offices. It was demolished in 1982.

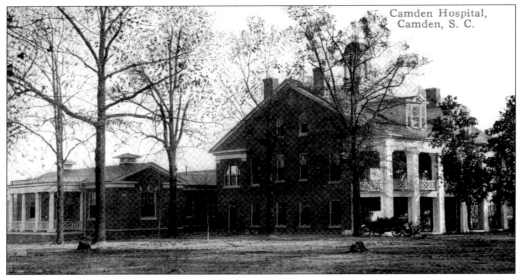

Camden Hospital, Camden, S. C.

CAMDEN HOSPITAL, [c. 1914]. Bernard M. Baruch, the son of Dr. Simon Baruch, gave $40,000 to erect a hospital building in honor of his father. The Presbyterian Manse on Fair Street near Union Street was purchased, veneered with brick, and expanded with additional wings to create a modern hospital. It opened on December 13, 1913 with both father and son present. The structure was destroyed by fire on January 28, 1921. Baruch then donated another $25,000, and local and Northern visitors gave the remaining funds to rebuild the hospital. The new hospital was built at 1722 Fair Street at Union Street.

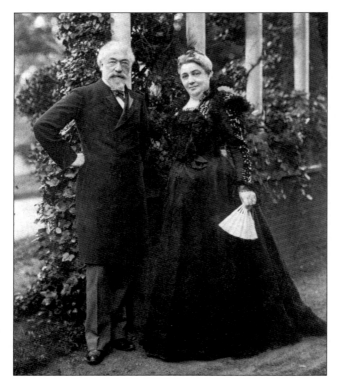

[DR. & MRS. SIMON BARUCH, c. 1900]. Dr. Simon Baruch (1840–1921) was born in Prussia, migrated to the American colonies, and graduated from the Medical College of Virginia in 1862. He served as a surgeon in the northern Virginian army and returned to Camden to practice for 15 years. He was president of the South Carolina Medical Society in 1873 and chairman of the state board of health in 1880. In 1921 he moved to New York City where he became an outstanding physician, surgeon, medical staff chief, and professor.

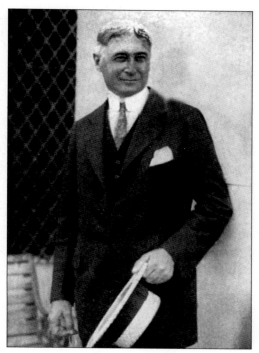

[BERNARD BARUCH, *c.* 1940s]. Bernard Baruch (1870–1965) was born in Camden and graduated from the College of the City of New York in 1889. He amassed a fortune as a Wall Street speculator and was a generous philanthropist. President Woodrow Wilson appointed him to public office in 1916. Baruch was a financier, statesman, and advisor to seven presidents through the 1960s.

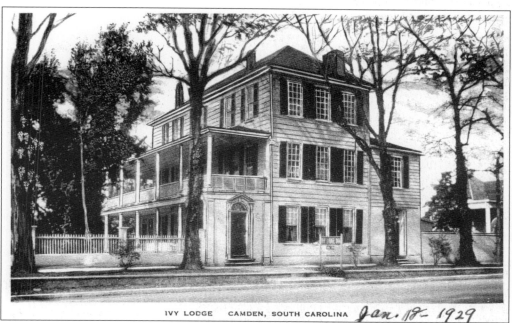

IVY LODGE CAMDEN, SOUTH CAROLINA *Jan. 18 - 1929*

Ivy Lodge, [*c.* 1915]. The home that later became known as Ivy Lodge, a three-story Charleston-style house with piazzas facing a garden, was built *c.* 1820 by Benjamin Bynum. It became the Camden home of Dr. and Mrs. Simon Baruch and the place where Bernard M. Baruch was born. This 1205 Broad Street residence later became a boarding house for Northerner visitors. It was demolished in the 1950s.

[REV. MONROE BOYKIN, C. 1890]. Monroe Boykin (1825–1904) was born as an enslaved person in the Boykin family. Judge Withers married Elizabeth T. Boykin, and their heirs donated two tracts of land to Monroe. Rev. Monroe Boykin was a member of the Camden Baptist Church until he was chosen to be the first pastor of Mt. Moriah Baptist Church. He was a missionary who established most of the older African-American Baptist churches now existing in Kershaw, Lancaster, Sumter, and Clarendon counties. A granite shaft was erected in his memory in front of the Mt. Moriah Baptist Church.

MT. MORIAH BAPTIST CHURCH, [C. 1907]. Mt. Moriah Baptist Church was organized in 1866. Its first sanctuary was constructed in 1889 at 204 (1912 map) Broad Street. Prior to the Civil War, African Americans attended Camden Baptist Church, and in 1860, 166 of the congregation's 266 members were non-white. After the war, African Americans established their own churches throughout Kershaw County. Rev. Monroe Boykin was chosen to be the first pastor of Mt. Moriah Baptist Church and served from 1866 until his death in 1904.

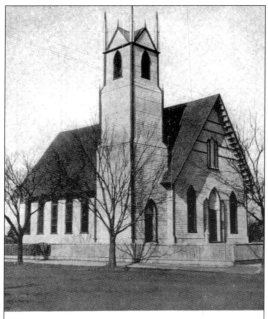

MOUNT MORIAH BAPTIST CHURCH
CAMDEN, S. C.
J. W. BOYKIN, PASTOR.

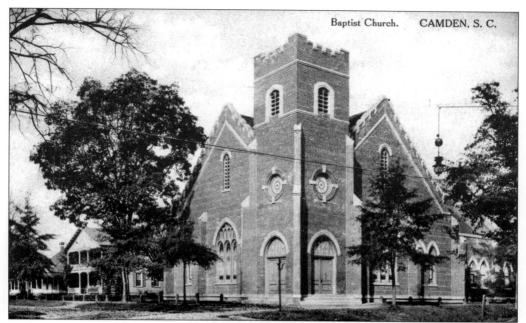

BAPTIST CHURCH, [*c.* 1909]. The Baptist Church's 1860 church congregation totaled 266 members, and they worshiped in the second building until 1908. Eventually, members decided that a larger church was needed. Thus, the old hall was sold in 1907, converted into an armory for the Kershaw Guards, and demolished in 1919. The membership met in the opera house during the construction of the new sanctuary. A new red brick semi-Gothic edifice was dedicated in February 1908 at a cost of almost $16,000. The 1908 sanctuary was used until 1966, when it was razed. The church has been known as First Baptist Church of Camden since 1950.

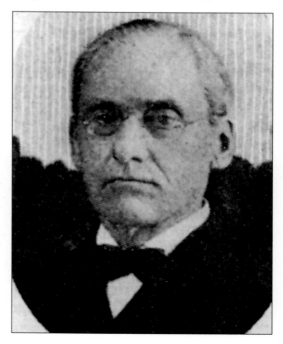

[REV. JABEZ FERRIS, 1902–04]. The Camden congregation withdrew from the Charleston Association to help found the Santee Baptist Association closer to home in 1876. They later joined the Kershaw Association in 1905. Turn-of-the-century pastors were M.W. Gordon (1891–1894), A.T. Jamison (1895–1900), A.E. Crane (1900–1901), and Rev. Jabez Ferris (1902–1904). Ferris started fund-raising for the new 1908 church.

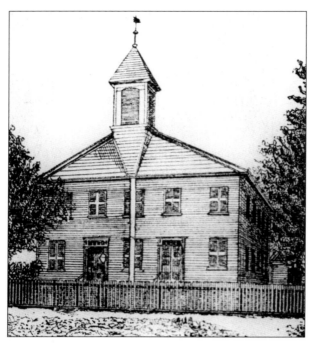

[METHODIST CHURCH, WEST DEKALB STREET, *c.* 1915]. Methodism was brought to Camden when Bishop Francis Asbury held his first service in April 1787. Rev. Isaac Smith was sent to Camden in 1787, and Camden was included in the Santee circuit. "Circuit riders" would visit the settlements at irregular intervals. The first frame structure on King Street was built by 1800. The second frame edifice, shown left, was built in 1828 on West DeKalb Street. The white congregation decided to sell this frame structure in 1872 to the African-American Methodist congregation, who used it until 1925 when it was razed and replaced by a brick structure.

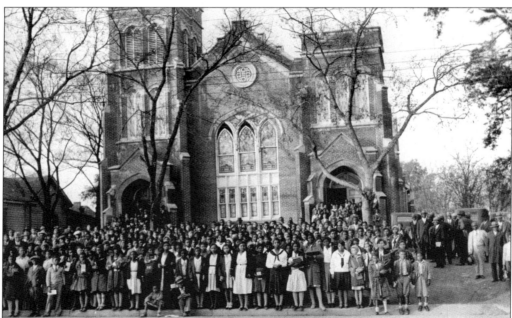

[TRINITY METHODIST EPISCOPAL CHURCH, *c.* 1930s]. Trinity Methodist Episcopal congregation was founded in 1866. In 1869, it hosted its first annual conference, which included over 1,300 participants. The first building that housed this congregation was the 1828 Camden Methodist Church, a frame structure they purchased in 1872 and used until 1925, when they built this brick edifice that became the Trinity Methodist Episcopal Church. This scene shows a 1930s temperance rally for youth at the church on 704 West DeKalb Street.

[JEFFERSON WITHERS BOYKIN, *c.* 1940s].
Rev. Jefferson Withers Boykin
(1868–1951) was the son of Rev. Monroe
and Mary Ann Boykin of Camden. He
graduated from Richmond Theological
Seminary in 1893 and did missionary
work in Kansas and South Carolina.
Boykin married Cora Sandridge of Virginia
in 1896. He succeeded his father as pastor
of Mt. Moriah Baptist Church on June 24,
1900, where he remained until his death
on June 12, 1951.

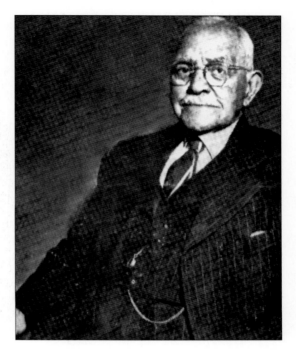

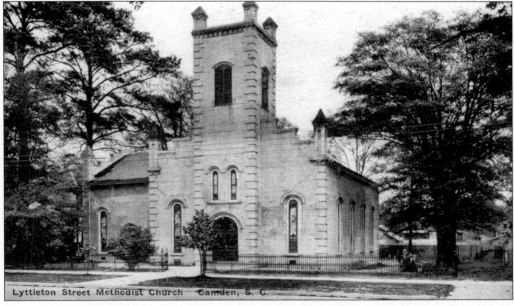

Lyttleton Street Methodist Church Camden, S. C.

LYTTLETON STREET METHODIST CHURCH, [*c.* 1907]. Before the Civil War all Methodists attended the sanctuary on West DeKalb Street. The white congregation decided to sell their frame structure in 1872. By 1875, the congregation had 125 members. Frederick Hay drew the plans for the Lyttleton Street Methodist Church, and in 1879 Rev. H.F. Chreitzberg gave a dedication. Rev. J.O. Willson (1878–1880) was the first pastor in the sanctuary above. The church was enlarged in 1896; the brick exterior was plastered in 1899; and Sunday school rooms and the steeple were added in 1900.

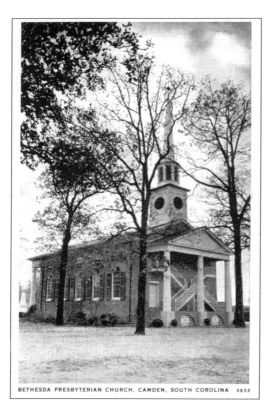

BETHESDA PRESBYTERIAN CHURCH, CAMDEN, SOUTH COROLINA 3933

BETHESDA PRESBYTERIAN CHURCH, [C. 1908]. An initial Presbyterian meetinghouse was in place in the 1770s. Rev. John Logue was the first minister and was succeeded by Rev. Thomas Adams. A record book states that Bethesda Presbyterian Church was organized in 1805 and a sanctuary was built soon afterwards, with Rev. Andrew Flinn beginning his stay there in 1806. After the congregation had grown, a larger sanctuary was needed. In 1820 a new site on DeKalb Street was obtained, and a sanctuary was erected and dedicated in 1822. The monument to Gen. Baron DeKalb was placed in front of the church in 1825.

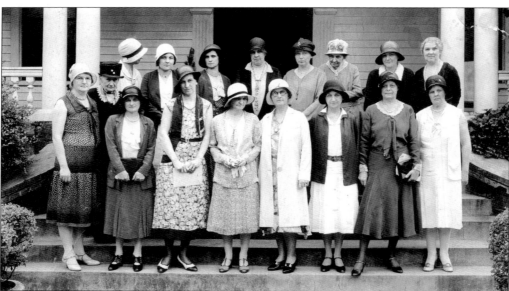

[LADIES CIRCLE, BETHESDA PRESBYTERIAN CHURCH, C. 1920]. The ladies circle of the Bethesda Presbyterian Church organized in order to be able to respond to the special needs of the congregation, problems in the local community, or missions beyond their county. This picture was taken in front of the McCreight home on Lyttleton Street.

[JOHN M. GAMEWELL, C. 1880]. John M. Gamewell (1822–1896), son of pioneer Methodist minister John Gamewell, had a book store in Camden. In 1843, he was appointed postmaster; he then became Camden's manager of the Washington and New Orleans Telegraph Company. In later years he sought and obtained patents for the Gamewell fire alarm telegraph in the United States, Canada, and England.

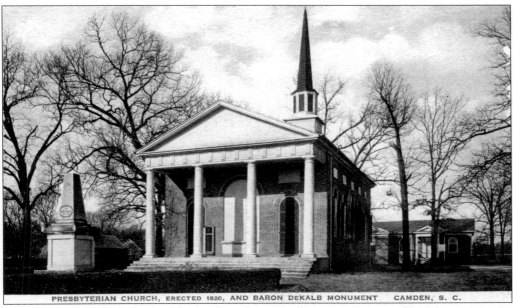

PRESBYTERIAN CHURCH, ERECTED 1820, AND BARON DEKALB MONUMENT CAMDEN, S. C.

BETHESDA PRESBYTERIAN CHURCH, [C. 1910]. Rev. John Joyce, minister from 1820 to 1822, was the moving force behind the construction of a new and larger Presbyterian sanctuary. In order to fund the $14,000 structure, pews were named and sold for a year's use at $30 and $15. Robert Mills designed the edifice in 1820, and it was dedicated in 1822. His design featured a portico and four Doric front columns, a spire in the rear, and two outside stairways leading to the second floor gallery where the organ and choir were located. The pulpit was situated between the two front doors. The interior was modernized in 1890. One of the brick academies is visible in the background.

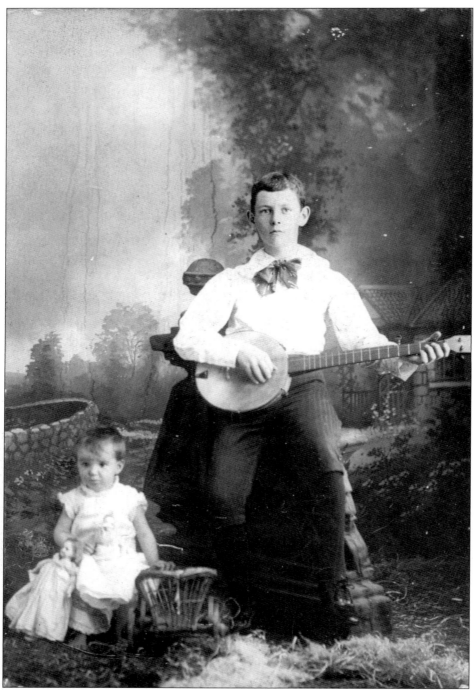

[DONALD AND WILLIE ALEXANDER, C. 1890s]. This William Alexander studio photograph is of William's nephew Donald (1880–?), son of Dr. Isaac Henry Alexander (1848–1920). Donald is seated on a pediment, right, and holds a banjo, while William's youngest daughter Willie (1889–1953) is seated left with a doll. A classical pastoral backdrop creates a nostalgic scene.

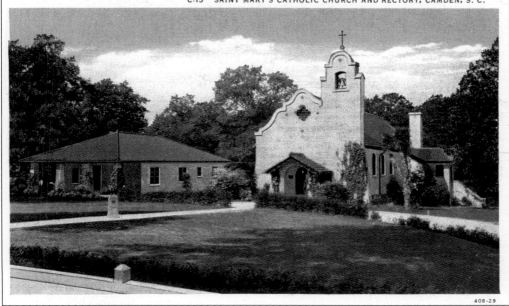

408-29

SAINT MARY'S CATHOLIC CHURCH AND RECTORY [1915]. When Miss Charlotte Thompson intended to build a new Catholic church, she bought a lot and had the J.J. Cain Construction Company of Columbia build a brick stucco Spanish mission-style structure at a cost of $15,000. Measuring 25 feet by 76 feet, this sanctuary could seat 200 people and was dedicated by Rev. T.S. Hegerty in 1914 or 1915. It is now called Our Lady of Perpetual Help Catholic Church and stands at 1709 Lyttleton Street. The initial building and lot on lower Lyttleton Street was sold and is now used as a Jewish Synagogue.

[CHARLOTTE M. THOMPSON, c. 1925]. Charlotte M. Thompson moved to South Carolina in 1909. As an active member of the Roman Catholic Church, she decided to have a more attractive and useful chapel built that might attract a larger congregation. She also donated her home, "The Terraces," to the county as a replacement schoolhouse after a disastrous fire destroyed nearby Cleveland School and killed 77 children and adults in 1923. Thompson died in 1926.

79

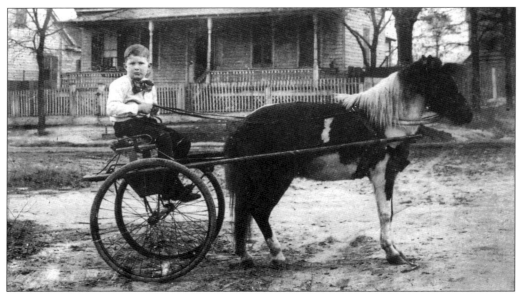

[**BOY ON A PONY CART**, *c.* **1915**]. The pony cart was a standard prop used by photographers to solicit business. The photographer would inform those living on a certain street that he would pass by on a particular time and day, and mothers would dress up their children for family pictures. The postcard above documents this activity.

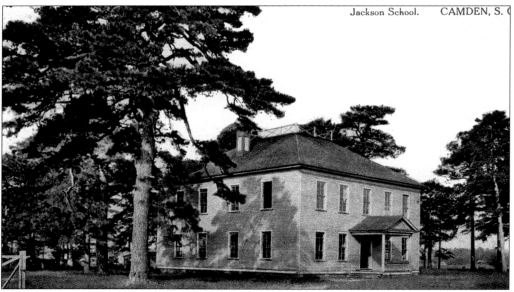

Jackson School. CAMDEN, S. C

JACKSON SCHOOL, [*c.* **1908**]. Jackson School, begun as a small frame building located at Campbell and DeKalb Streets, was established in 1867 as a result of Rev. B.F. Whitmore's efforts. It was incorporated into the public school system in 1893. The school had 8 grades, 5 teachers, and 453 students in 1900. As seen in the postcard above, the original building was replaced by a two-story frame structure with six classrooms in 1903 and was valued at $3,800. In 1923, Jackson High School was built beside the wooden elementary school, which was replaced by a two-story brick structure in 1936.

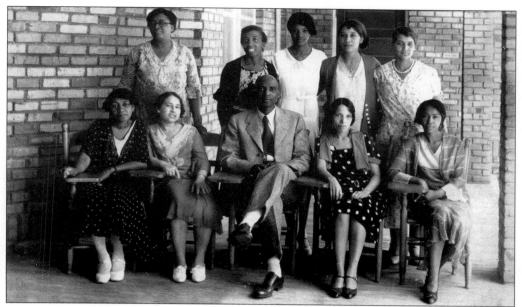

[FACULTY, JACKSON HIGH SCHOOL, 1931–1932]. The picture above includes part of the 1931–1932 faculty of Jackson High School. The teachers are, from left to right, (seated) Mrs. Sallie Peyton, Mrs. Addie Ransom, P.B. Mododana (principal from 1918 to 1951), Miss Ethel Winningham, and Mrs. Ada Duren; (standing) Miss Katie C. Powell, Miss Rosa Aaron, Miss L.M. Finch, Miss Mabel English, and Mrs. Mable Stover. The 1903 faculty salary was $360 for the male principal and $180 for each of the female teachers.

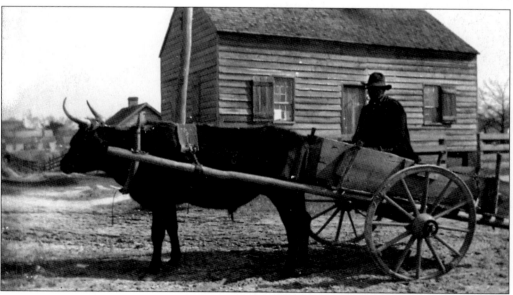

[MAN ON AN OX CART, C. 1900]. An ox cart was a standard mode of transportation for farmers of limited means who needed to carry produce to market. This Camden scene also shows some of the simple tenant housing. The no-frill frame structure probably was a two-room home that fulfilled no more than the basic necessities of keeping the weather out and the family dry.

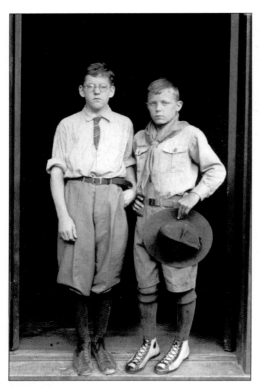

[BOY SCOUTS, 1926]. Boy scouts George Rhame (left) and Joseph W. Jenkins (right), photographed in 1926, were members of troop #54. Mr. John deLoach and Mr. W.F. Nettles served as the scout leaders. The senior boy scout assistants were Walter Rhame and Benton Burns. A partial list of other troop members includes Homer Baldwin, Ansel and Layton Bateman, Julian Burns, Jack Haile, J. Louckin, and H. Osborne. They met at the Boy Scout Hut behind a home on Fair Street.

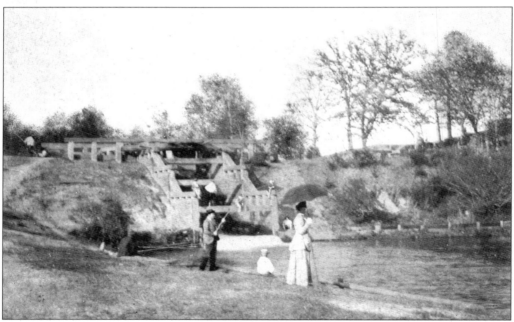

[FISHING SCENE, c. 1880s]. This 1880s Alexander photograph shows an idyllic scene below the dam, where a proper gentleman is fishing in the creek and a lady in fashionable clothing is watching the children. This scenario was not typical among most of Camden's citizens.

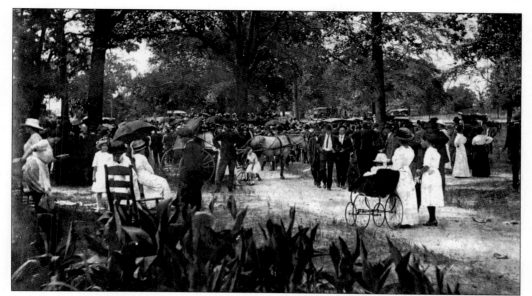

[**PARK EVENT,** *c.* **1912**]. This scene in the park was photographed at a political rally meeting *c.* 1912, which was held in the southwest section of Monument Square. The town meeting/social event attracted those interested in seeing the candidate and hearing him give his message in person. At this time only registered white men could vote.

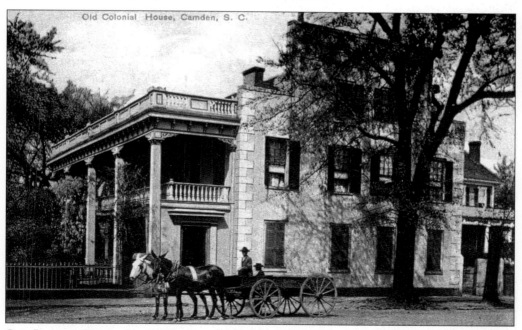

OLD COLONIAL HOUSE, [*c.* **1908**]. Greenleaf Villa, 1307 Broad Street, was a Charleston "double-house" with a Dutch-gabled roof facing Broad Street. It was built *c.* 1815 by Samuel Flake, who gave it fluted freestanding wooden columns that went from the ground to the top of the second-story piazza. The carved wooden balustrades enclose the piazzas with carpenter lace ornaments. Many postcards of beautiful homes like the one above were sold in the local drug stores.

[TEMPLE BETH EL SYNAGOGUE, C. 1920]. The building that first housed the Sacred Heart Catholic Church was erected at 1501 Lyttleton Street in 1903. It was obtained by the Hebrew Benevolent Association in 1921 and became Temple Beth El Synagogue. Rabbi J.H. Hirsch of Sumter served the Camden congregation in 1921. It has been remodeled into a Spanish mission structure and is still in use. Twenty-four families belonged to the Hebrew Benevolent Association in 1877. In 1880, Mrs. Simon Baruch started a Hebrew school for youth.

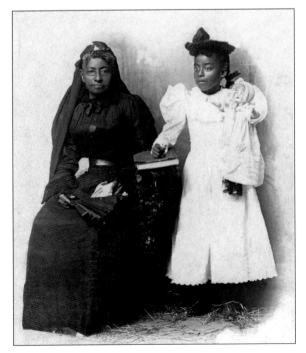

[LADY AND CHILD IN MOURNING CLOTHES, C. 1900]. This studio portrait of a lady and young girl in mourning dresses shows the fashionable styles of 1900. The lady in black wears a silk floor-length dress with a veil over her head and extending to her waist, and she wears fingerless gloves on her hands. The girl is dressed in a white lace-trimmed cotton dress. Notice how she holds a doll with a white dress in her left hand while her right hands rests on a Bible.

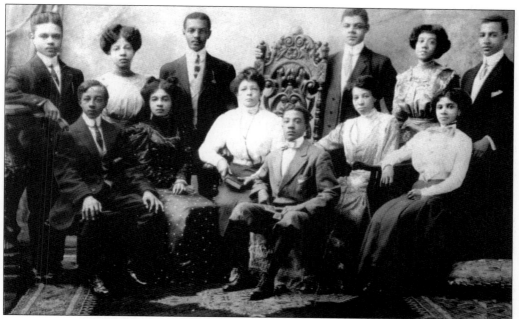

[WILLIAM W. CARTER FAMILY, C. 1907]. In 1874, William W. Carter (b. 1853) married Harriet Josephine McLaughlin (1856–1917), the daughter of Mary Elizabeth Vaughan of Camden. William and Harriet became the parents of 12 children, and here Harriet is photographed with 11 of them. William was licensed as a certified teacher by the county board of examiners in September 1870. He later became a school principal and commissioner of education during the Reconstruction period. Nightriders set fire to their home, and the family moved to New York.

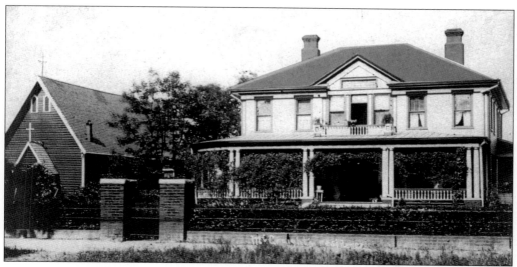

[CATHOLIC MISSION & HOUSE, C. 1910]. Attempts to build a Catholic Church were not successful before 1884. In 1903, Sacred Heart Church (shown above) on 1501 Lyttleton Street was dedicated and used until 1914. Rev. T.J. Hegerty of Columbia was the rector of the mission, and Rev. B.W. Fleming was the curate. Since it was a frame building, it was not consecrated. The house at the right of the mission belonged to the McCreight family.

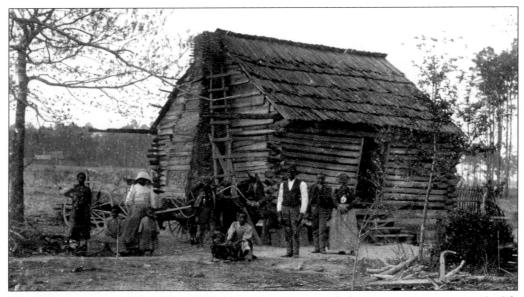

[CABIN & FAMILY, *c.* 1880s]. This 1880s Alexander photograph documents a moment in the life of an African-American family. Several generations lived in an old, one-room log structure. Their mule-drawn wagon waits to haul produce to market, and in the front center one of the girls cooks something in the iron kettle.

[MOTHER AND THREE CHILDREN, *c.* 1890s]. This is a portrait of an attractive young mother and her children dressed in the finest clothing. Snyder Gallery photographs (*c.* 1902–1910, and later called Camden Studio, 1910–1914) made this studio portrait. They are probably members of the Boykin family.

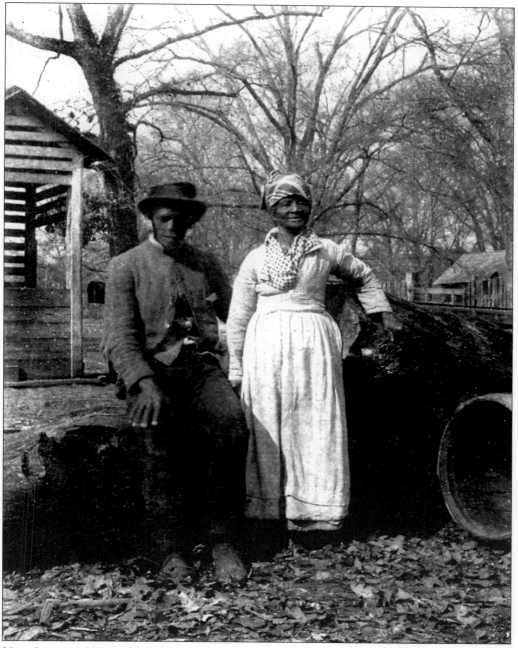

[OLD COUPLE, 1880s]. This 1880s Alexander portrait shows an African-American family posing in their best clothing by a fallen tree trunk. This scene of daily life was regularly encountered by those walking along Campbell Street.

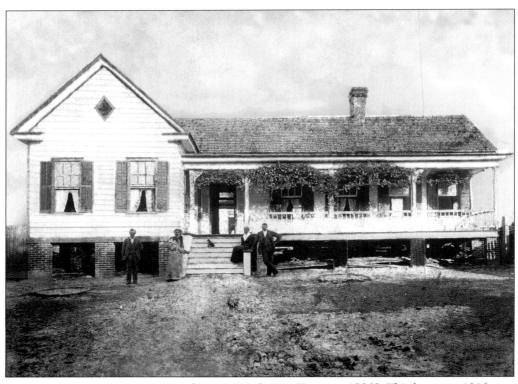

[ANDREW H. DIBBLE HOME, c. 1892]. This house at 1216 Campbell Street was the residence of Andrew Henry Dibble Sr. (1825–1873), formerly of Charleston, and his wife Ellie Naudin Dibble (1828–1920). They purchased it from James Dunlap in June 1863. This sizeable home was the family residence for more than 60 years. Ellie N. Dibble is seated on the side of the steps, and her children (from left to right) William, Harriet, and Eugene stand with her.

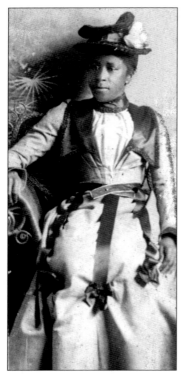

[BOYKIN LADY, c. 1890s]. This unidentified member of the Boykin family poses in a very elegant dress. Since women could not purchase ready-made garments, they needed to either make their own clothing or go to a dressmaker such as Mrs. S. Tweed. This silk garment includes a dark-colored jacket, and the collar is opened to show a lace blouse. The waist has a belt supporting dark ribbons that extend down over the skirt.

[**William E. Boykin**, *c.* **1890s**]. William Ellison Boykin (b. 1857) was the son of the Reverend Monroe and Mary Ann Boykin. He married Mattie Carter (b.1857), the daughter of Mary Jane George and Henry Carter of Camden. William and Mattie became the parents of five girls.

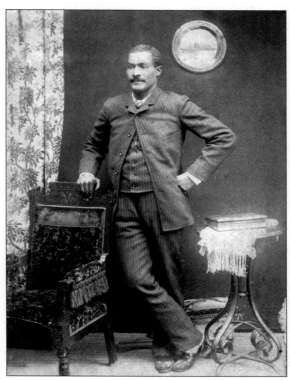

[**Birchmore House**, *c.* **1907**]. Charles W. Birchmore (1860–1931) was a descendent of Thomas Birchmore, who was a member of Capt. Francis Blair's company in the War of 1812. Charles Birchmore established the *Wateree Messenger* beginning in October 1884, and continued publishing it until 1931. He built this house at the corner of 1110 Fair Street and East DeKalb Street. It no longer stands.

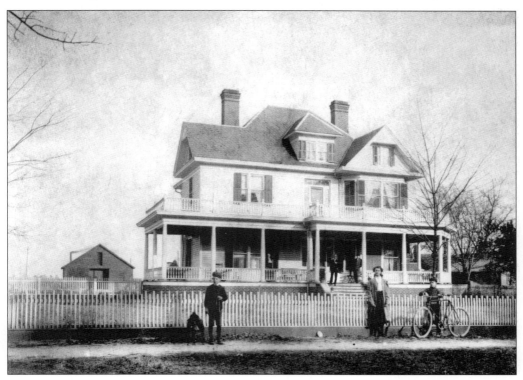

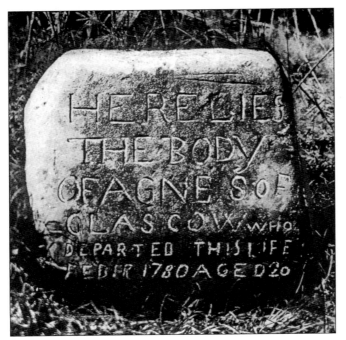

[AGNES OF GLASGOW'S TOMBSTONE, C. 1910]. The headstone of Agnes of Glasgow near the Quaker Cemetery relates to the legend of a romantic quest. The story tells of a 20-year old British girl who said goodbye to her lover, Lt. Angus McPherson, when he left England to join his company in Charleston in 1780. Lovesickness drove her to cross the ocean and overcome many obstacles until she arrived at Cornwallis's camp in Camden. There, Agnes found Angus dead on his cot. It is said she died of a broken heart, and she was buried near the old Presbyterian Meetinghouse site in Camden.

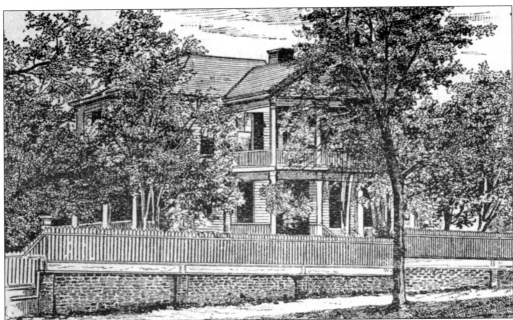

[LAFAYETTE HALL, C. 1900]. Henry Cook built this residence on Broad Street, north of DeKalb Street, in 1821 and sold it to John Carter in 1823. On March 8, 1825 General Lafayette came to Camden to participate in the dedication ceremonies of the DeKalb Monument and stayed in this home. Later it was the home of the James Dunlap family. The house was destroyed by fire in 1903. In 1906, the Kershaw County courthouse was built on this site, which was replaced by the 1966 courthouse.

BROWNING TABERNACLE, 1924. Evangelist Raymond Browning came to Camden during August and September of 1924 and raised a tent that he called the "Browning Tabernacle." The postcard view above was sold by Browning to raise additional income. His religious revival attracted many converts.

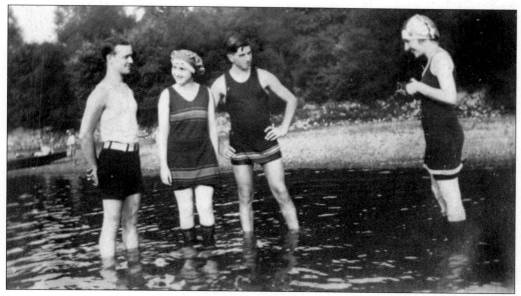

[SADDLE AND PADDLE, *c.* 1920]. The "saddle and paddle" area was the name Camden's young men gave to a section of the "old factory pond" where they swam. Initially, swimming suits were optional for males. Later, when women began swimming there, bathing suits were required and women's suits often extended to their ankles. By 1912 some women began wearing form-fitting suits.

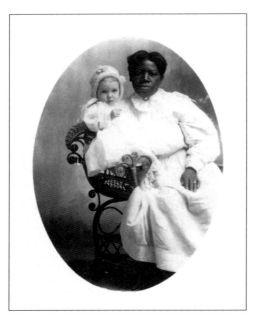

[NURSE AND CHILD, C. 1905]. It was a social custom among affluent turn-of-the-century families to hire nurses who would care for babies and young children, allowing wives to direct their attention to other family activities. The picture shows Emily Jenkins and the family nurse, who, in the family's early years, traveled with them as they moved from city to city.

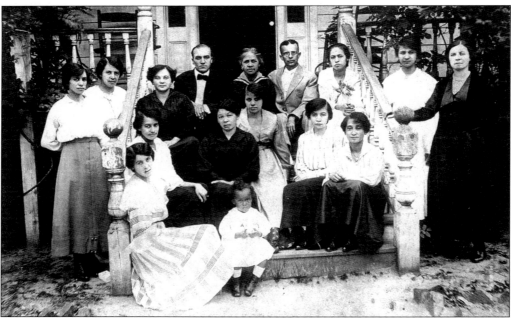

[GEORGE WESTON McLAIN FAMILY (1917)]. George W. McLain (1847–1917) was the son of Jane Johnson (1832–1907) and George McLain Sr. Jane was Scotch-Irish, and George Sr. was of German Jewish heritage. He married Rebecca Deas (1849–1889) and later Elizabeth Lloyd (1858–1951), both of Camden. In the photograph at their home at 1413 Lyttleton Street are his surviving wife and 14 of the 17 children, born between 1870 and 1900. George owned the G.W. McLain & Sons Barber Shop at 1045–1049 Broad Street. According to a 1914 Camden news article, the shop was "the oldest established enterprise in Camden." The article also stated that (at the time) George was 67 year old and that he had been a "barber for 47 years."

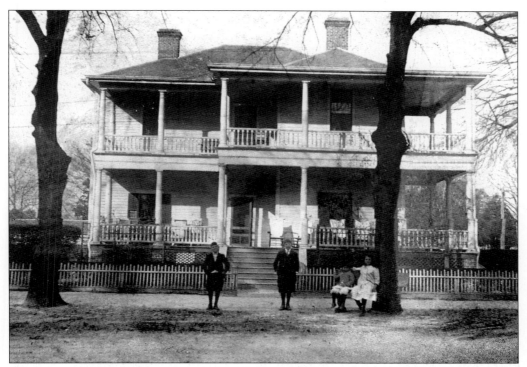

[**HARRY L. SCHLOSBURG HOUSE,** *c.* **1916**]. This two-story frame house was built in 1904 as the residence of Harry L. Schlosburg (1877–1940). The Schlosburg family was a member of the Temple Beth El Synagogue and owned the Schlosburg Department Store ("Cotton Carnival") at 944–946 Broad Street beginning in 1894. The store sold dry goods, clothing, shoes, etc. Later, the house became the Marion-Frances Inn and then an apartment house. It was razed in 1968.

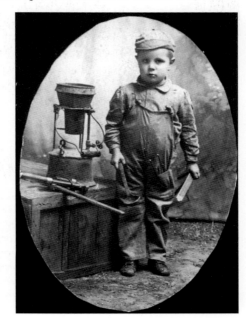

CHILD WITH TOOLS, [*c.* **1913**]. This is a portrait of John F. Jenkins (1905–1942), grandson of George G. Alexander, at age 13. John was born in Camden and moved with his family to various cities for several years. Later he joined the merchant marines and died during World War II.

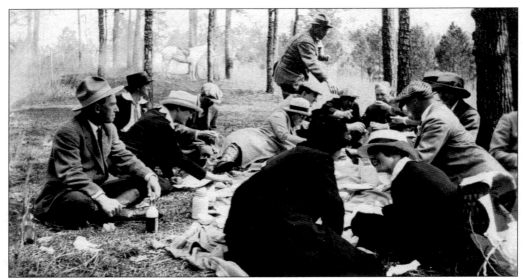

[EQUESTRIAN PICNIC, *c.* 1910]. The winter residents and local equestrians—at least those who were not handicapped by business or professional engagements—enjoyed equestrian activities and sports. Some of the events included horseback riding on bridle trails, horse shows, Gymkhana events, and fox hunting. This allowed them to escape daily routine and freely ride through the countryside. Often during these adventures they would pause for a picnic before returning to work or home.

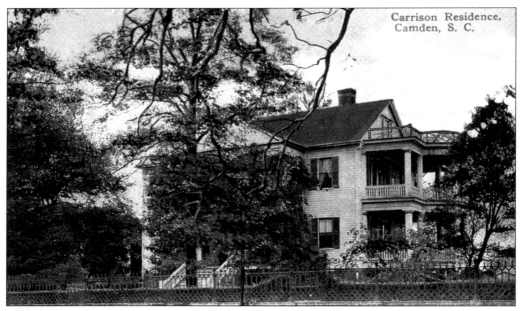

CARRISON RESIDENCE, [*c.* 1908]. The Carrison residence was built for C.J. Shannon (1783–1863) at 1502 Broad Street. It became the home of Henry G. Carrison (1851–1937) while he was president of the Hermitage Cotton Mill (1905–1911). Later, he was president of the Bank of Camden (1888–*c.* 1929). This postcard shows an excellent example of the prestigious mansions built by the wealthy planters, financiers, and mill owners of that era.

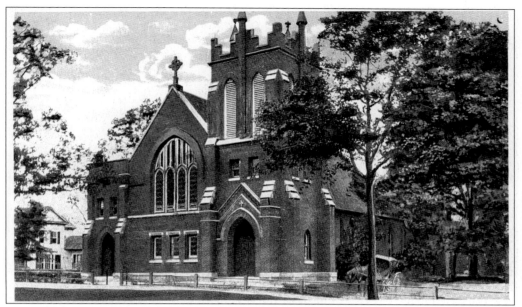

GRACE EPISCOPAL CHURCH, [c. 1910]. Following the national trend, the name of the Anglican Church was changed to Episcopal. A local congregation was formed in 1830, and the first rector was Edward Phillips. The first church on Broad Street was destroyed by fire in late 1867. In 1873, a new church with a Gothic brick design was erected at 1315 Lyttleton Street and continues in use. The ornate front and corner tower was added in 1908.

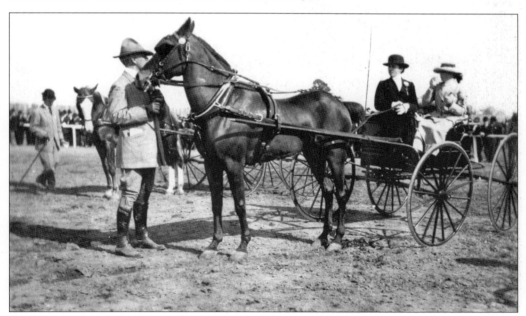

[HORSE AND BUGGY, c. 1905]. At the turn of the century, most middle- and upper-income families used the horse and buggy as their means of daily transportation. Often families would have a stable, horses, and related supplies and equipment. Most large stores also had livery stables in back of their buildings for the use of the customers and staff.

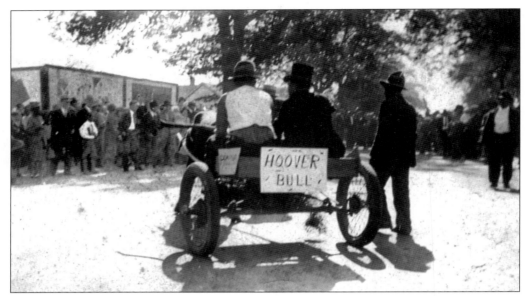

[HOOVER BULL, *c.* 1930s]. The above postcard view of a "Hoover buggy" was photographed during the Depression era, when Herbert Hoover was president (1929–1933). The owners substituted automobile parts for the traditional wagon cart. Groups of 40 to 50 "Hoover buggies" were included in Camden parades during this period.

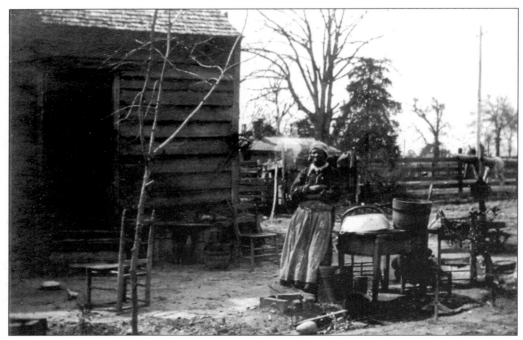

[WASH WOMAN, *c.* 1890s]. The scene above was photographed near the outer edge of Camden, where the domestic help lived. It shows an elderly woman's cabin and her wash area. Here she would boil the soapy water to wash clothes, then rinse and hang them to dry before returning them to each family.

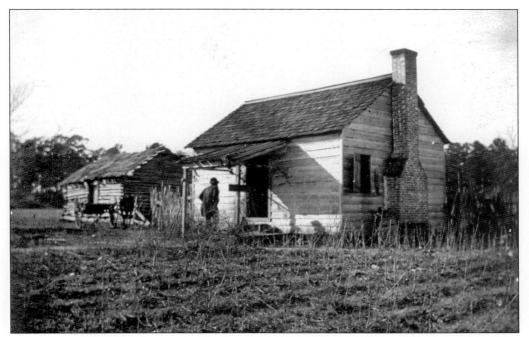

[**RURAL HOUSE AND BARN, *C*. 1905**]. This image of a small farm family's simple well-crafted frame cabin was taken in the fall, when the fields that surrounded their home lay barren. A mule and cart stand in front of the barn to the left side of the cabin.

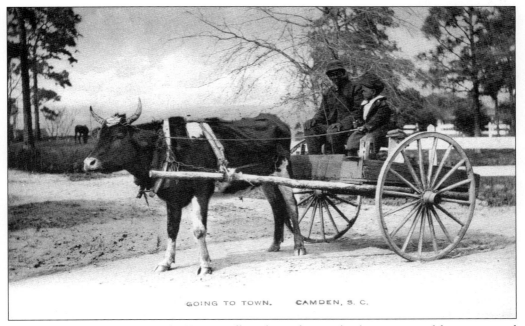

GOING TO TOWN. CAMDEN, S. C.

RIDING ON AN OX CART, [*C*. 1908]. A small traditional two-wheel ox cart used by some rural families is shown here. The postcard's title "Going to Town" suggests that they are delivering some produce to a market in Camden.

GOAT MAN [*c.* 1930]. The Goat Man was Charles (Ches) McCartney of Zebulon, Georgia. He lived the life of an old-fashioned gypsy peddler, and his family would travel with him as he went from town to town, selling pots and pans and doing small chores for food money. A team of goats pulled the wagons piled high with goods, tents, and personal items while the family walked down the roads. Both the Goat Man and his child wore goatskin clothing and slept by the side of the road. The postcard above was sold by Ches to make money. Children along his extended route through Georgia and South Carolina marveled at the carnival lifestyle of this unusual man.

DOLPH BRIDGES HOME, [1907]. This postcard of Dolph Bridges's home (*c.* 1890s) is an example of the pre-1900 log structures that were built as less expensive first-homes by many families. The house may have evolved from a one-level log unit with the second story added later, when it was needed. The Bridges family members are posed on a wagon on the far left, and a log barn appears at the right of the house.

Three
MATHER ACADEMY

During the final decades of slavery, it was a crime to teach a slave how to read and write. At the conclusion of the Civil War, most of the freed slaves were illiterate and did not have the means to educate themselves. Miss Sarah Babcock of Plymouth, Massachusetts came to Camden in 1867 as a missionary to open a school that would be founded by the Northern Methodist Church for the children of former slaves. She purchased a 27-acre plantation that included a mansion built by Thomas Lang in 1814 (shown below). Miss Babcock returned to New England and later became the wife of Rev. James Mather. In 1883, the New England Southern Conference of the Women's Home Missionary Society was organized and Mrs. Mather became the corresponding secretary. The society supported the Mather Academy, which opened in 1887. In 1889 the New England Southern Conference purchased the 27-acre tract from Mrs. Mather for $2,000. The Boylan-Haven-Mather Academy closed in 1983.

THE BROWNING AND MATHER HOMES, [c. 1907]. This postcard shows the second building, the Browning Home, on the left and the initial Lang Residence, renamed the Mather Home, on the right. These structures became the model home and industrial school on property owned by Mrs. Mather. They were on Campbell Street, between DeKalb and York Streets. The Browning Industrial Home and Mather Academy were opened in 1887. A chapel was built in 1900 with dorm rooms for the boys. The first boys enrolled in the school were J. Maxwell, I.B. English, and G. McLain in 1890. These facilities were supported by gifts of Mrs. Mather and her sister, Lucy Babcock. Mrs. Mather died in 1901.

BROWNING HOME, [c. 1910]. Mrs. Fanny O. Browning gave $2,000 to complete a school building (shown in the above postcard) that stood on the property owned by Mrs. Mather. It was later called the Browning Home. The Mather Academy was opened in 1887 as a boarding and day school. Four girls graduated at the first commencement in 1893.

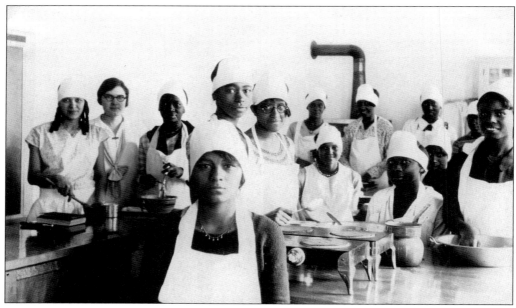

[COOKING CLASS, MATHER ACADEMY, 1928]. The missionary teachers taught their students reading, writing, and mathematics so that they could earn a living in the changing turn-of-the-century society. Cooking skills were also taught so that students would have the option of taking domestic or commercial lunchroom employment in the future.

100

[**Mrs. Wilder**, *c.* **1930**]. Miss Mary Tripp was the first superintendent of Mather Academy. Other superintendents included Mrs. E.D. Clark, Anna Gordon, Miss Frances Viola Russell (who was superintendent for 30 years beginning in 1890), and Miss Lula B. Bryant (who served from 1939 to 1952). Teachers included Miss Emma V. Levi (1887) and Miss Achsa Greenfield, who took numerous pictures of activities and events during the 1928–1929 school year. Mrs. Wilder, seen on the right, was superintendent from 1929 until 1930.

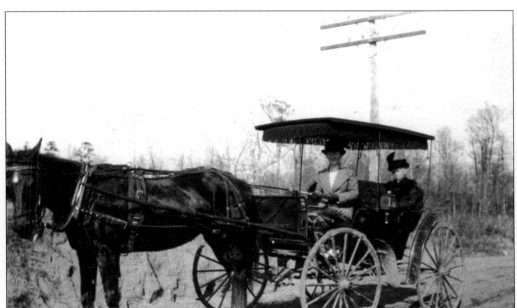

[**Going to Ephesus, Mather Academy, 1928**]. Miss Frances Russell served Mather Academy from 1890 to 1930. She established Sunday schools and industrial classes at two nearby sites, Ephesus (west of the Wateree River) and Wesley Chapel (south of Camden, near Mulberry Plantation). Her plantation work gave hundreds of children and young people a head start.

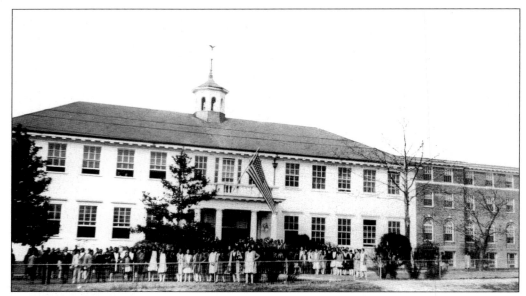

[HUBBARD HALL/BROWNING HALL, C. 1930]. Hubbard Hall, above, was built and dedicated in 1912. It was financed by a gift from Mr. S.H. Tingley as a memorial to his wife, whose maiden name was Hubbard. It contained classrooms, recreation rooms, parlors, a dining room, music room, cooking lab, gymnasium, and chapel. The new laundry, domestic science, and lunch rooms were luxuries. In 1928 the school built a new four-story brick academic building, which is seen behind Hubbard Hall, and added the 12th grade.

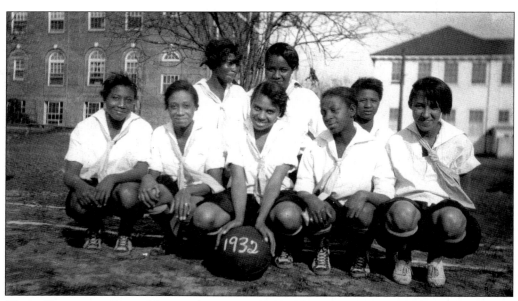

[GIRLS BASKETBALL TEAM, MATHER ACADEMY, 1932]. The gymnasium provided the academy students a place to develop athletic skills. The first team sport was a girls basketball team in 1932. The boys basketball team was not organized until 1935. They called themselves the Mather Eagles, after the eagle adorning the building's weather vane.

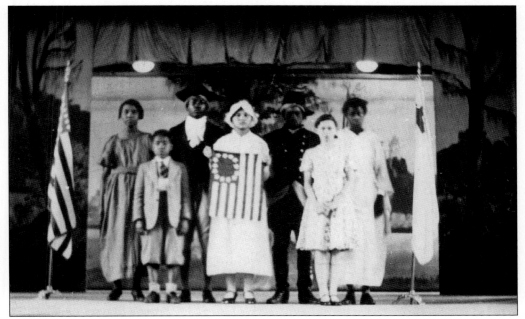

[PLAY, MATHER ACADEMY, c. 1928]. The missionaries teaching at Mather Academy used many techniques to instruct the students in religious, historical, and patriotic studies. The auditorium was used for assemblies to hear visiting speakers on current and historical subjects. The student body enjoyed musical events by local or academy choirs. Student plays that highlighted religious and patriotic themes were planned to aid in cultural instruction.

[SEWING CLASS, MATHER ACADEMY, c. 1920s]. Sewing was one of the domestic skills that the missionaries taught their students. They were shown how to hand and machine sew, use patterns, weave fabric, and assemble and fit a garment to the specific measurements of an individual. These skills were desirable for domestic or commercial employment.

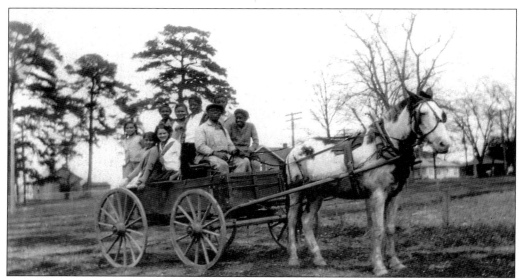

[BROWNIES ON A FIELD TRIP, *c.* 1920s]. When students of the Browning Home/Mather Academy went on a field trip around Kershaw County, they would use the academy's wagon. These trips would usually involve a class project, commercial demonstration, religious meeting, or a visit to a historic site.

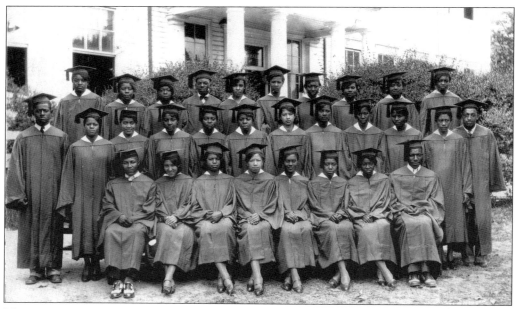

[GRADUATES, MATHER ACADEMY, 1930s]. In 1928, Mather added a 12th grade and became the only accredited black secondary school in South Carolina. Mather graduates migrated to all sections of the United States. Missionary teachers like Miss Lula Bryan, who was principal from 1927 to the 1950s, continued to correspond with former students and traveled far across the nation to see alumni. After 96 years (1887–1983) of educating African-American children, the Boylan-Haven-Mather Academy closed in 1983. The academy building was razed in 1993, when it was deemed a fire hazard.

Four
RESORT ERA

Kirkwood is a section north of Camden, located on a sandy hill away from the swamplands and the mosquito/malaria problem that existed in lower Camden. Merchants in the 18th century built summer homes here. Beginning in the 1890s, a tourist colony of Northern industrialists, financiers, and equestrians came to Camden to enjoy the mild winter climate and pursue their athletic interests. They bought and built large homes and stables. The new infusion of wealth influenced local business, transportation, industry, and expanded the resort structure. Their presence also added to cultural opportunities.

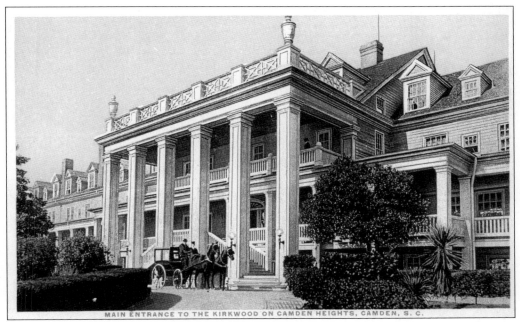

MAIN ENTRANCE, KIRKWOOD, [*c.* 1910]. The colonial home of Maj. John Cantey was located on the west leg of Greene Street, off upper Broad Street (the western section of the Hobkirk Hill's battlefield). The home came into the possession of the Camden Land Improvement Company in 1903, and they converted the residence into a hotel. The addition of two large wings gave it 150 rooms and a capacity of 275 guests. It became the largest and most prominent hotel for tourists in Camden and was a hub for social and cultural activities. T.E. Krumbholz was the manager until his death in 1923. He was succeeded by K.P. Abbott.

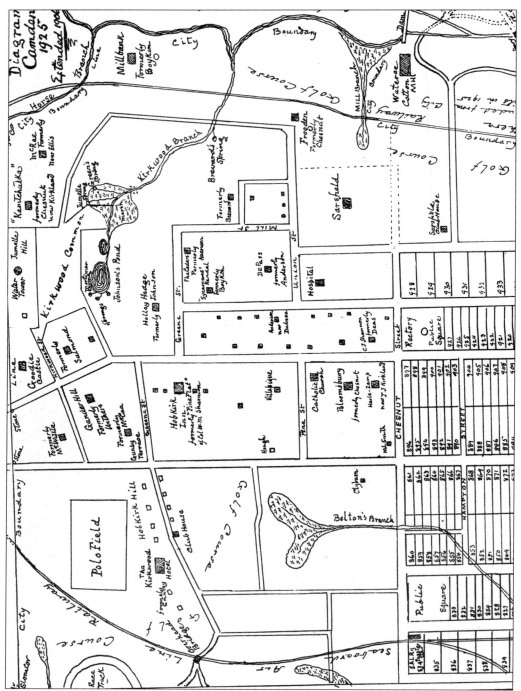

[MAP OF KIRKWOOD AREA, 1925]. This 1925 map of the northern Kirkwood section of Camden shows the locations of tourist hotels, prominent homes, churches, the Wateree Mill, and the hospital. It also shows the initial sites of golf courses, polo fields, and the race track, as well as the layout of city streets. (*Historic Camden*, vol. 2.)

106

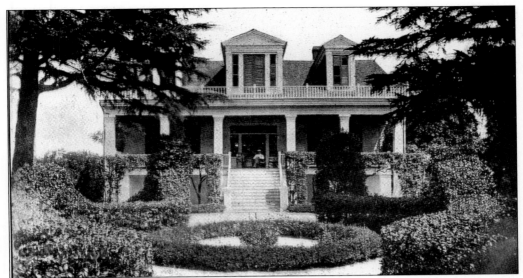

"HOLLY HEDGE," [*c.* 1910]. A three-story mansion was constructed of pine and brick in 1842 by W.E. Johnson (1797–1871) at 302 Greene Street. This 32-acre estate, including springs used by American troops before the battle of Hobkirk Hill in 1781, had English formal gardens. Hedges and terraces outlined walkways, small pools, and statuary. It became the winter residence of Mrs. Marion duPont Scott, who stabled and raced her horses in Camden. She renamed it "Holly Hedge."

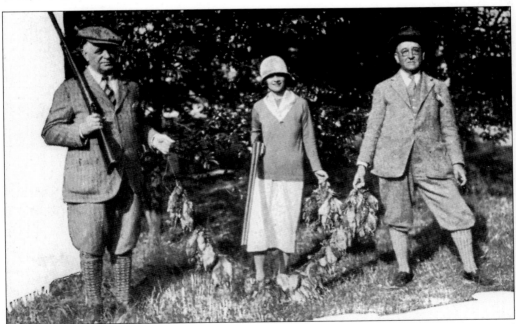

[SHOOTING FOWL GAME, *c.* 1908]. Many Northern sportsmen visiting Camden requested hunting trips while on their winter vacations. The hotel management hired local hunters to take visitors to sites that had concentrations of quail and doves. This way, visitors could return home with memories of successful hunts.

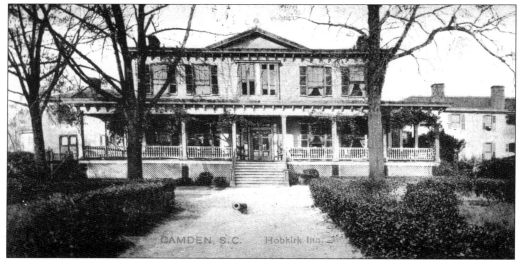

HOBKIRK INN, [*c.* 1908]. The Kirkwood mansion, built in an Italianate style and located at 1919 Lyttleton Street, was built in 1850 for William Shannon, who named it "Pine Flat." Located near the middle of the Hobkirk Hill and south of Greene Street, it became Camden's first tourist hotel and was run by F.W. Eldridge in 1882. Later, individual guest cottages were built and the nearby "Goodie Castle" was purchased for overflow winter guests. A golf course was built in 1897. Though the main house still stands, the hotel closed just before World War II.

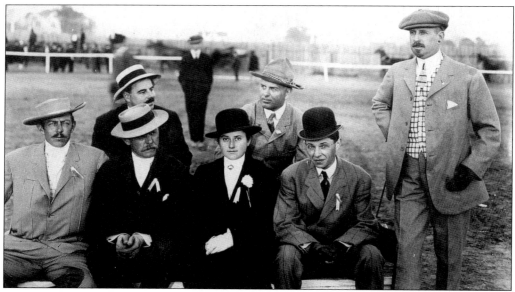

[CAMDEN HORSE SHOW, 1909]. The first fair was held in 1775 at the old fair grounds on Fair Street. This site was used for many horse shows. A partial list of first-place winners at the Camden Horse Show of 1909 included the following: class #1, "Golden Rainbow," G.T. Little, Camden; class #12, "Cinderella," C.P.L. West, Camden; class #17, "Lula Marion," G.T. Little, Camden; and class #18, "Jack O-Lantern," R. Rowley, Greenville. This 1909 show was the first that began a series of annual Camden horse shows, which still continue as of 2002. This official portrait shows the first stewards who set the standards for all of the ensuing shows.

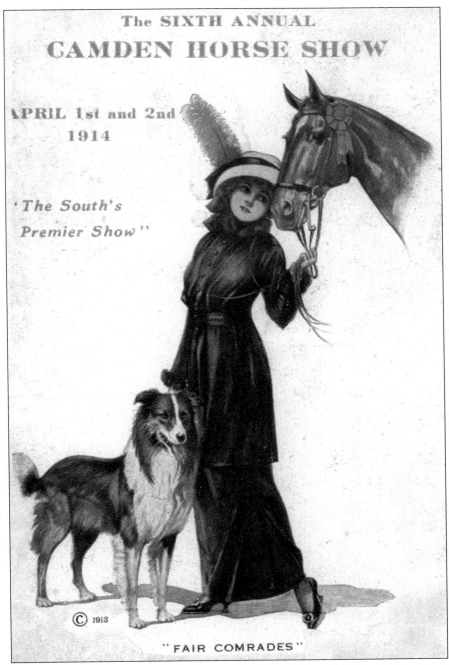

The SIXTH ANNUAL
CAMDEN HORSE SHOW

APRIL 1st and 2nd
1914

"The South's
Premier Show"

© 1913

"FAIR COMRADES"

SIXTH ANNUAL CAMDEN HORSE SHOW, 1914. The Camden Polo Club and the South Carolina Horse Show Association sponsored the sixth-annual Camden Horse Show. This was the association's first show of the annual South Carolina circuit. Sam Riley of Atlanta was the judge and awarded the Harness Championship's "Banker Cup" to "Tidal Wave," owned by J.N. Kirvin of Darlington. The Saddle Championship's "Schiller Cup" was awarded to "Lula Marion," owned by G.T. Little of Camden, who bought the Kentucky championship-winning horse for $1,250.

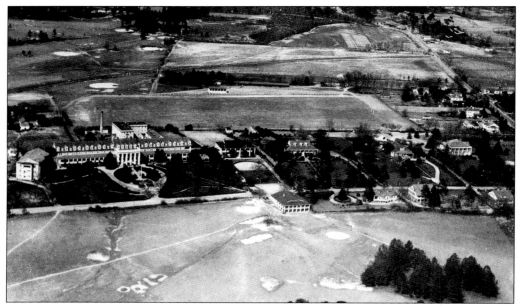

[AERIAL VIEW, KIRKWOOD GROUNDS, *c.* 1920]. The Kirkwood Hotel grounds contained the Camden Country Club, an 18- and 9-hole golf course, a racetrack, polo field, and stables. Their cottage colony consisted of beautiful small houses and bungalows that accommodated up to 10 to 20 persons. Kirkwood was used as a headquarters for U.S. army field maneuvers in the 1940s. It was then closed and taken down in 1945.

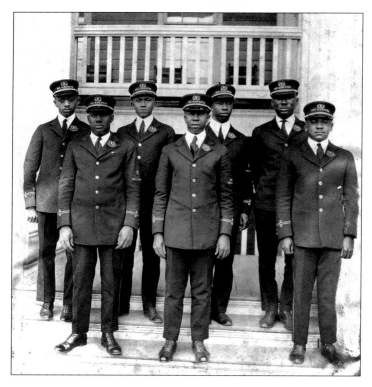

[GAMBEL BROTHERS, *c.* 1930s]. The Gambel brothers became Kirkwood Hotel employees and spent most of their lives working for there in various capacities. Their duties ranged from superintendent of service and bell captain to attendants dealing with every facet of the resort.

110

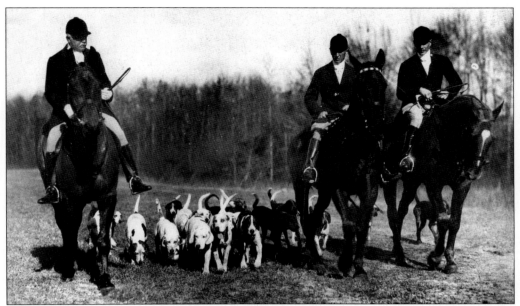

[**DRAG HUNTS,** *c.* **1920s**]. Drag hunts have been held in these rolling sand hills since 1845. This equestrian hunting sport involves a man riding a mule and dragging a fox-scented bag on a 20-mile circuit early in the morning. Mounted horse riders then follow well-trained hounds as they track the scent. The Camden Hunt (established in 1926) has organized hunts through the years. The three sportsmen, from left to right, are Lamont Dominick, Andrew Leach, and Carroll Bassett.

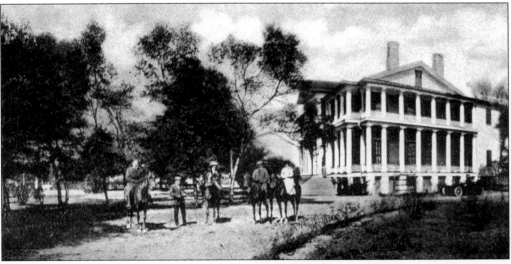

COOL SPRINGS, [*c.* **1910**]. Cool Springs Plantation is located three miles north of Camden. The name traces back to Sarah Nesbit's original grant in 1767. The first house was destroyed and then rebuilt in 1832 by John Boykin. Cool Springs was enlarged in 1853 and remodeled by Rueben Hamilton (architect) for James B. Cureton. It had first- and second-story piazzas on three sides, all supported by 72 columns. A spring is located on the grounds. Some years later a riding ring and other facilities were built, making it ideal for horse shows.

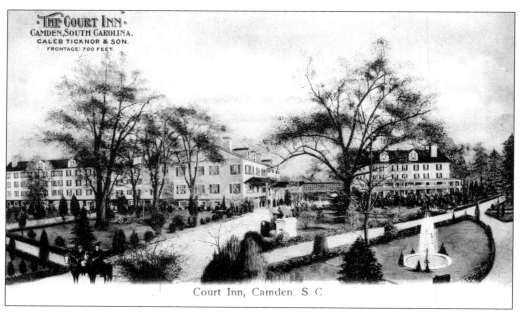

THE COURT INN
CAMDEN, SOUTH CAROLINA.
CALEB TICKNOR & SON.
FRONTAGE: 700 FEET.

Court Inn, Camden, S. C

COURT INN, [*c.* 1908]. "Lausanne" was built on Mill Street in 1830 by John McRae. It then became the residence of Major J.M. DeSaussure. Mrs. Callie J. Perkins purchased the house in 1889, and opened it as Camden's second major tourist hotel. She called it Upton Court, and it served as an elite and desirable home for "particular" tourists. Mrs. Perkins died in 1898; Caleb Ticknor then took over the hotel and renamed it Court Inn. In 1900 it had a capacity of 200 guests. It was condemned and razed in 1964.

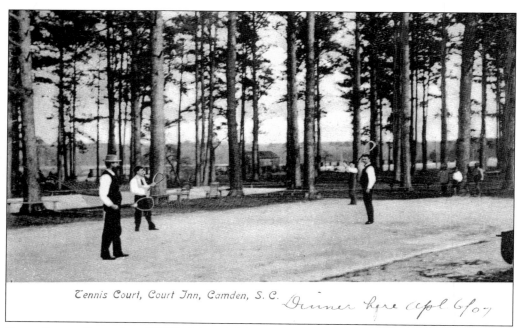

Tennis Court, Court Inn, Camden, S. C. *Dinner here apl 6/07*

TENNIS COURT, COURT INN, [1907]. When Caleb Ticknor took over the Court Inn, he decided that tennis courts would be a popular attraction for Northern sports-lovers.

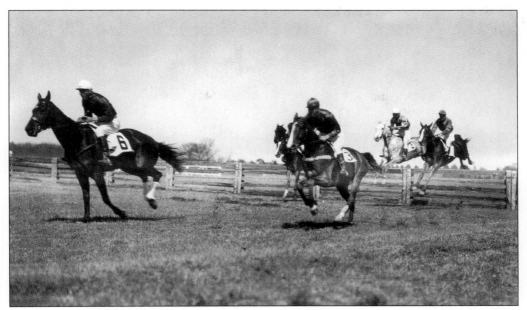

[CAROLINA CUP, 1933]. The 1933 running of the fourth Carolina Cup was won by "Pink Tipped" (#6), owned by R.K. Mellon, trained by J.E. Ryan, and jockeyed by William Street. The three-mile distance race was run in 5.52 minutes. The second place horse was "Sunset 2" (#3) owned and trained by Harry D. Kirkover and ridden by Randolph Duffy. The attendance was 15,000.

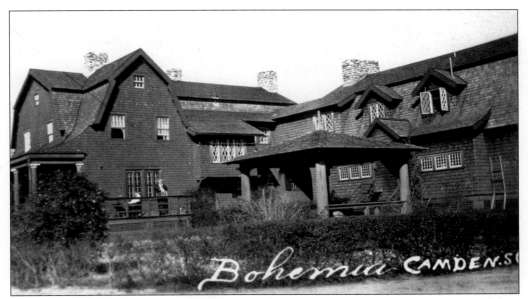

"BOHEMIA," [c. 1907]. Roger L. Barstow (a wealthy winter resident) built a home, stables, and private exercise ring for horses across from the Hobkirk Inn. The shingled Dutch colonial house had a Mansard roof and an elaborate ballroom. Barstow (1875–1961) named the house "Bohemia." He spent a lot of time developing the art of horsemanship and treated his horses well. This postcard was used by Barstow for personal correspondence.

113

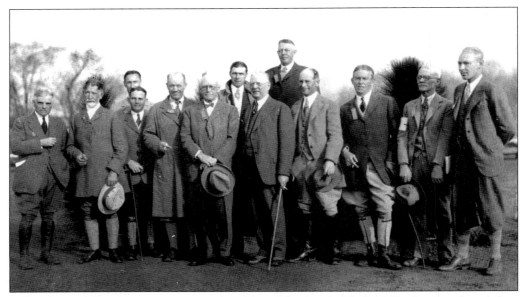

[STEWARDS, 1928]. The 1928 patrons (stewards) of the Springdale Race Track were, from left to right, (first row) Harry Kirkover, Carroll Bassett Sr., M. Larrabee, McKee Graham, H.G. Woyd, Mr. ? White, Samuel Russell, Ralph Chase, George T. Little, and Henry Savage Jr.; (back row) Myron Wick, unidentified, and C.M. Taintor. These men raised, trained, and raced their horses in Camden and other tracks across South Carolina, and they often won the purses.

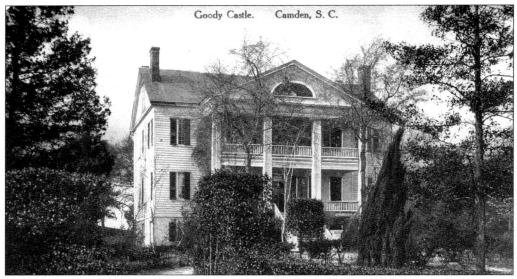

"GOODIE CASTLE," [c. 1908]. Thomas D. Salmond (1783–1854) was the first president of the Camden branch of the State Bank. He purchased land from Col. John Kirkwood in 1818 and built a two-and-a-half-story clapboard mansion (c. 1820). It was located near Kirkwood Lane and Lyttleton Street. The house had three piazzas and large square pillars that went from ground to attic levels. Benjamin Perkins acquired the house in 1844. It was sold to Estelle Eldredge, who was nicknamed "Goodie," in 1884. She let Hobkirk Inn use the house as an annex and named it "Goodie Castle." It was demolished in 1959.

114

[WASHINGTON PLATE RACES, 1934]. The first place winner of the February 1934 Washington Birthday Plate Race, a two-mile hurdles race, was "Hotspur II." The plate trophy went to his owner, Mrs. W.A. Wadsworth. The horse was trained by Harry D. Kirkover and jockeyed by Stewart Janney.

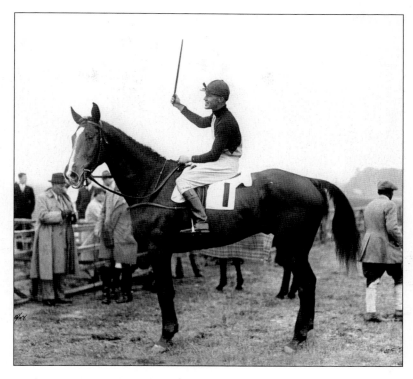

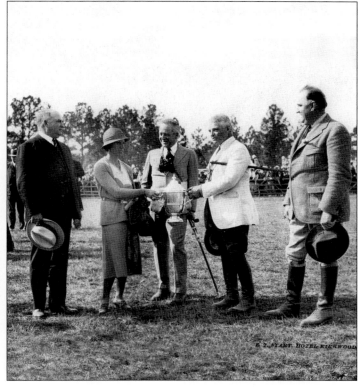

[WINNER, CAROLINA CUP, 1932]. The first Carolina Cup race was held in 1930. "Ballast II" was the winner, and "Sea Soldier" won the cup in 1931. The winner of the 1932 Carolina Cup was "Troublemaker," owned by Marion DuPont Sommerville (Scott) and ridden by Noel Lang. The trophy presentation scene shows, from left to right, Gov. I.C. Blackwood, Marion Sommerville, Ernest Woodward, Harry D. Kirkover, and David R. Williams Sr. The Queen Anne silver trophy cup was made in Ireland in 1702 and purchased in 1930. A replica of the trophy is awarded to each year's winner.

115

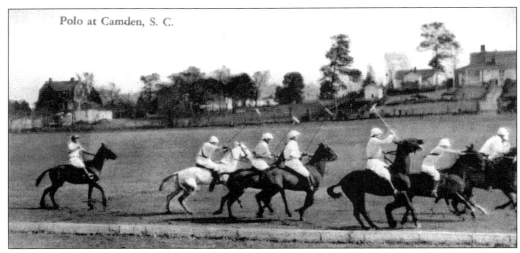

Polo at Camden, S. C.

POLO IN CAMDEN, [c. 1908]. Polo was introduced to Camden in 1898 by Roger L. Barstow. The first polo field was located behind the Hobkirk Inn; however, it and the second field were abandoned for a third field located on Polo Lane and still in use in 2002. Barstow provided his own string of 22 ponies, and others brought horses to make at least two teams of players. Polo was usually played twice a week, and no admission was charged. Teams from South Carolina and other states continue to play in Camden tournaments.

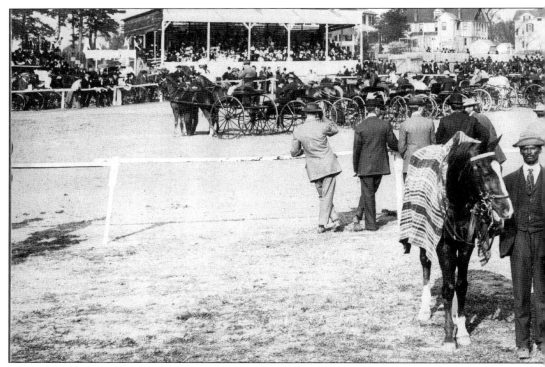

[HORSE EVENTS, c. 1908]. Horse racing was a sport among early Camden gentlemen. James Kershaw detailed races in his diary from 1802 until 1812. The Camden Jockey Club was recorded in the 1816 *Camden Gazette* when it elected its officers. In 1857, the South Carolina Jockey Club

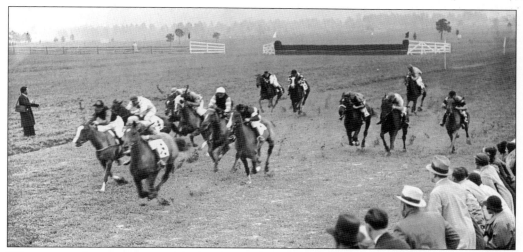

[**WASHINGTON BIRTHDAY RACES, 1934**]. The Washington Birthday Races were run on a 400-acre complex. The 1934 winners were as follows: first place, "Hotspur II," owned by Mrs. W.A. Wadsworth and ridden by Raymond Woolfe; second place, "Emerald Isle," owned by Ernest Woodward and ridden by Carroll Bassett; third place, "Sunset," owned by Harry D. Kirkover and ridden by Joseph Cotton; and fourth place, "War Mist," owned by Danwool Stable and ridden by J.V.H. Davis.

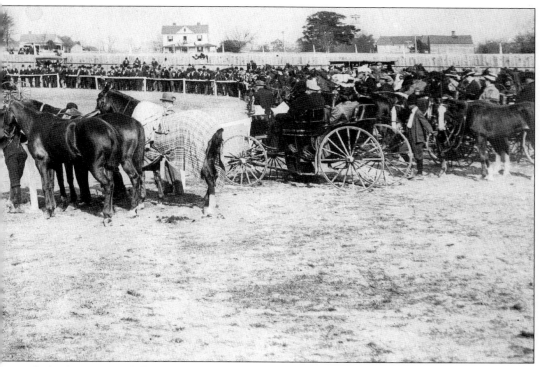

of Charleston stated that Gen. Zack Cantey had a stock of well-bred horses that often took the winning purses. Racing and breeding horses gained importance among gentlemen farmers, and that interest lasted for more than a century.

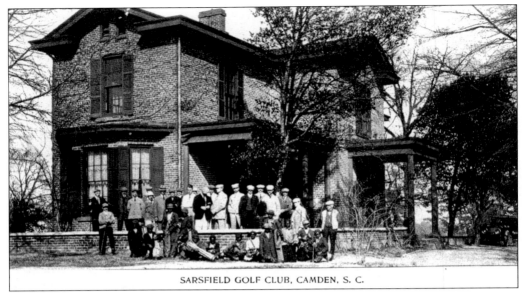

SARSFIELD GOLF CLUB, CAMDEN, S. C.

SARSFIELD GOLF CLUB, [*c.* 1908]. Sarsfield (1873) was built by Gen. James Chesnut (1815–1885), C.S.A, who resided in the home until he died. It was at this house that his wife, Mary Boykin Miller Chesnut (1823–1886), finished her journal entitled "A Diary from Dixie," which she kept during the Civil War. It became a primary source for leading historians and was used by Ken Burns for his award-winning PBS Series *The Civil War*. The Court Inn used Sarsfield as the clubhouse for the Sarsfield Golf Club, whose course surrounded the inn and extended towards the old Factory Pond.

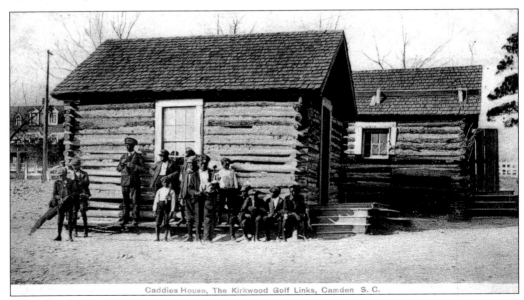

Caddies House, The Kirkwood Golf Links, Camden S. C.

CADDY CABIN, [*c.* 1908]. The Camden Golf Club designed these attractive rustic log cabins in a Southern plantation-style that Northern visitors would enjoy. They were at a site where young caddies could gather and wait for the golfers to select them. This postcard scene was published and sold in the hotel's gift shop.

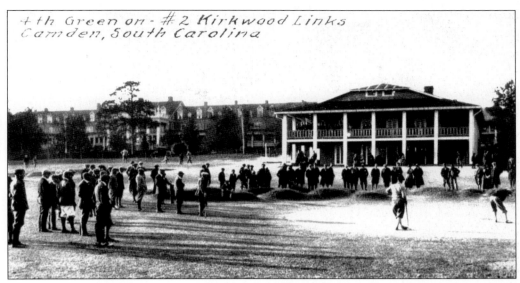

4th Green on - #2 Kirkwood Links
Camden, South Carolina

FOURTH GREEN, KIRKWOOD LINKS, [c. 1908]. The Camden club house and golf course were built on the grounds of the Camden Land Improvement Company, which faced the Kirkwood Hotel, in 1903. The 18-hole and 6,288-yard course was designed by Walter Travis. Travis used contoured greens and various hazards to create a scenic and challenging course that could be enjoyed by golfers of diverse skills. This postcard was sold at the golf club house.

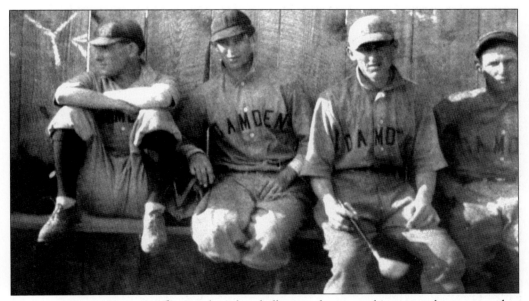

[CAMDEN BASEBALL TEAM, 1906]. Camden's baseball team, shown on this postcard, was a member of the South Carolina State League, which included teams from Darlington, Georgetown, Manning, Orangeburg, and Sumter. The 1906 schedule went from June 12 to August 19. That year, Camden won the pennant with a record of 40 wins and 17 losses (a .702 average). The pennant game was played at Camden's old fair grounds in front of a crowd of 1,500. Guy Gunter was the manager and center fielder and Richardson was their star pitcher, who held a record of 15 wins and 4 losses.

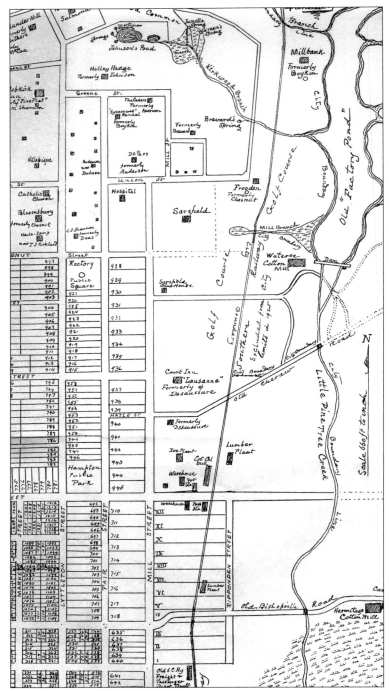

[MAP OF THE MILL AREA, 1925]. This 1925 map of the eastern boundary of Camden begins at the northern part of the old factory pond and the Wateree cotton mill. It shows the Little Pine Tree Creek and Mill Street, south to the Hermitage cotton mill and the northwest corner of Hermitage Swamp. (*Historic Camden*, vol. 2.)

Five
COTTON MILLS

The history of Camden's cotton mills begins with the DeKalb Factory, established in 1838. It was located at the western end of the dam that created the old Factory Pond on Little Pine Tree Creek. Production began with 1,000 spindles, which was increased to 1680 spindles and 40 looms to make yarn and cotton osnaburgs in 1846. The annual raw cotton consumption that year was 1,000 bales. The mill had 72 operatives and a monthly expense of about $900. The factory village housed 154 white inhabitants in small cottages. The factory burned before the Civil War. The second mill was the Camden [Hermitage] Cotton Mill (1890), which was followed by the DeKalb Cotton Mill, located by the first mill's site in 1900.

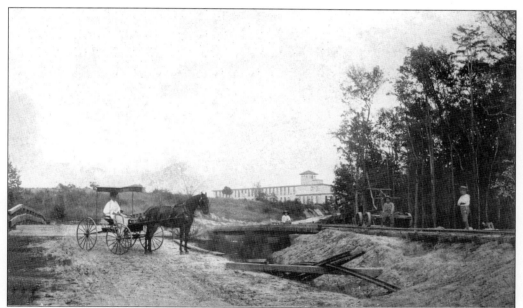

[VIEW OF CAMDEN COTTON MILL, 1890]. The 1890 distant view of the Camden Cotton Mill was photographed by W.S. Alexander. This rural scene has a horse and buggy standing by a plank bridge over a creek on the left and a two-man handcar paused on the initial railroad tracks and trestle on the right. The scene implies that the mill, in its construction phase, is an isolated structure frozen in time. Almost lost in the mists of the low swamplands, the view lacks the industrial clutter of debris, equipment, railroad cars, and cargo that will later spoil this pastoral scene.

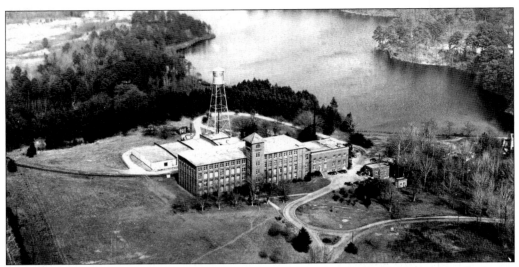

[AERIAL VIEW, WATEREE MILL, C. 1920s]. The old Factory Pond was the site of the DeKalb Cotton Mill, organized in 1899 and opened in April 1901. The facilities, designed by W.B. Smith Whaley of Columbia, cost $144,000. It began under local leadership with 12,500 spindles, 300 looms, and a village of 70 cottages. The mill printed high quality print fabric. The DeKalb Mill closed in 1903; it reopened as Pine Creek Mill in 1905 with 18,816 spindles and 482 looms, processing 3,000 bales of cotton annually. Financial problems in 1907 caused the Pine Creek Mill to change hands. After changing hands again in 1916, a Northern financial group headed by H.P. Kendall bought the facilities and renamed it Wateree Mill. Kendall Mills and village is on the National Register of Historical Places.

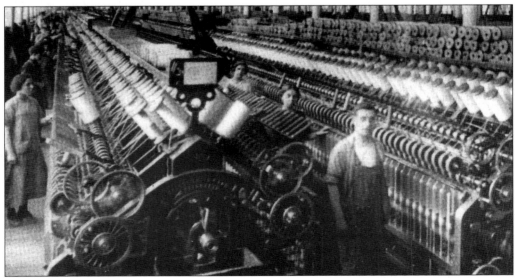

[INTERIOR, WATEREE MILL, C. 1921]. This interior view of the Wateree Cotton Mill shows the spinning department. Here spindles were used to blend cotton fibers into a cotton yarn, which was then woven into various types of fine quality print cloth. In 1921 the old plain looms were replaced by 420 new "E" model Draper automatics. In 1926 the mill had 21,316 spindles and 492 looms.

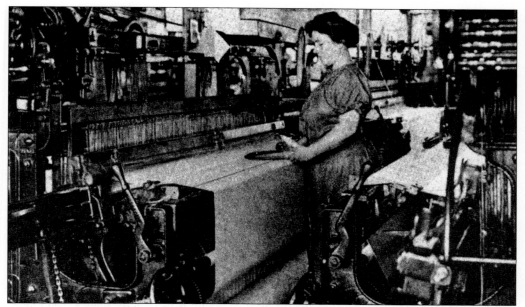

[WATEREE MILL WORKER, c. 1921]. In 1905, the Pine Creek Manufacturing Company employed 250 workers who lived among 104 houses in a village of 700 people. The annual pay roll was $55,000 in 1905. A two-week (12-day) salary was $8.64, or 72¢ per day, for carding machine operatives; $7.28, or 61¢ per day, for spinning machine workers; $6, or 50¢ per day, for spooling machine personnel; $11.04, or 92¢ per day, for weaving machine employees; and $9.12, or 76¢ per day, for drawing machine workers.

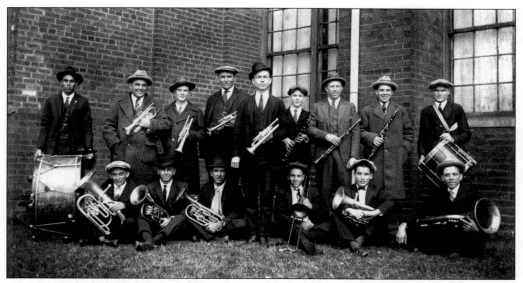

[MILL BAND, c. 1921]. The Wateree Mill band was organized in the 1920s after the Kendall Mills purchase. Their strong financial base meant these mills could afford the extra expenses of musical instruments, sports equipment, YMCAs, churches, and schools, as well as educational, cultural, and athletic activities. It was the first mill band in Camden and was requested to play in many parades and civic events.

123

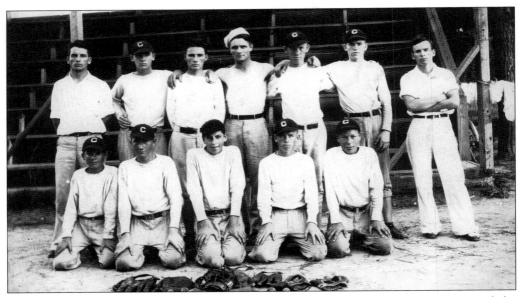

[MILL BASEBALL TEAM, *C.* 1921]. The Kendall Mill had a baseball team in the 1920s, and the employees and management enjoyed playing other civic and mill teams in the area. The enthusiasm and pride that operatives had in their teams created a happy and contented work force, which often meant higher production and profit for the mills. They played Columbia Mills, Darlington YMCA, Wheeler Hill Giants, and other regional teams.

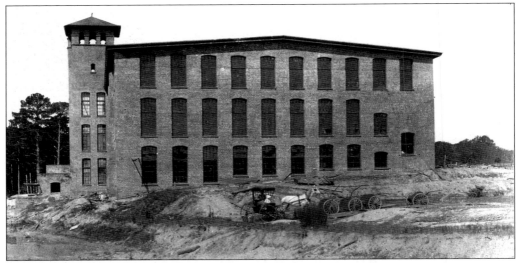

[CAMDEN COTTON MILL, *C.* 1890]. The Camden Cotton Mill at 125 Old Bishopville Road was built in 1890 by local businessmen. The three-story brick structure was built on a 1,400-acre site on Pine Tree Creek, which was dammed to create a 500-acre lake (now called Hermitage Mill Pond). The mill opened with 10,000 spindles, 300 looms, and 150 employees. In 1905 it was sold to a new organization and incorporated as the Hermitage Cotton Mill. By 1926, it had 16,000 spindles, 390 looms, and 250 workers, and it processed 3,500 bales of cotton annually. Its product was fine sheeting with an annual value of $235,000. It had a mill population of 400, an annual pay roll of $55,000, and a capitalization stock of $150,000.

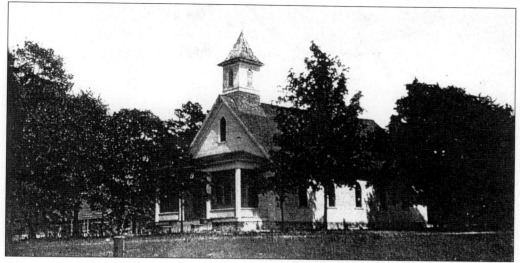

[WATEREE BAPTIST CHURCH, C. 1920]. The mill gave $200 and land near the village for a mill church, first known as Pine Creek Church. Mill village churches often started out as all-denominational, and local pastors conducted evening services. The Pine Creek Church building was used for day care during the week and as a site for men's and women's meetings. When Northern groups obtained insolvent mills, they often expanded the operatives' fringe benefits, such as sports, music, education, and entertainment. Similar to Northern mills, they documented such activities with photographs.

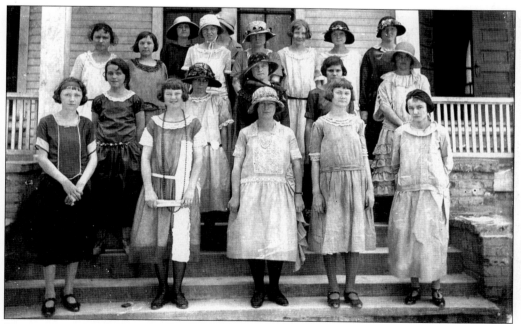

[WOMEN, WATEREE MILL, C. 1920]. This image of the Wateree Mill's women indicates that many of them had become seamstresses. They wore dresses and hats that reflected the latest styles of that day. These pictures were taken for public relations mailings that promoted Kendall's progressive leadership in their Southern Mills.

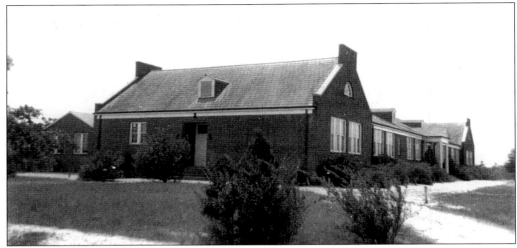

[PINE TREE SCHOOL, c. 1930]. The mill school began as a small frame structure for the children of the operatives. The factory school had 40 students enrolled in 1903. As the student body increased, a larger building was needed. In 1922 a factory school was erected midway between the two mills at a cost of $12,000 and was included in the city school system.

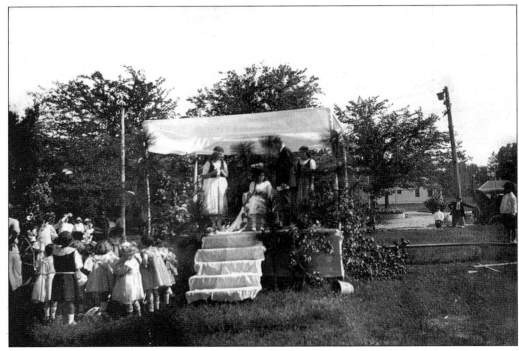

[MAY DAY PAGEANT, c. 1920]. May Day was a special event for Wateree Mill children. The special events and picnic altered the daily schedule of classes, recitations, and tests, making the day unique. The scene above shows H.K. Hallett, Wateree Mill superintendent from 1917 to 1924, placing the wreath on the head of the May queen, Gertrue Williford. The queen's attendants were Mary Barnes and Gladys Dority. Unfortunately, pictures of Hermitage Cotton Mill operatives were not located.

126

ACKNOWLEGMENTS

Many persons and institutions have contributed to the preparation of this book. We wish to express our gratitude to Allen Stokes, Robin Copp, and Thelma Hayes of the South Caroliniana Library University of South Carolina. Other essential contributions were made by Agnes Corbett and the staff of the Camden Archives and Museum; Joan and Glen Inabinet; Joanna Craig at the Historic Camden Revolutionary War Site; Charles Baxley and members of the Kershaw County Historical Society; Elsie Goins of the Naudin-Dibble Heritage Foundation (who contributed the images on pages 35, 36, 37, 72, 75, 84, 85, 86, 88, 89, and 91); Marty Daniels of the archives at Mulberry Plantation; and Hope Cooper of the National Steeplechase Museum.

Other essential contributions were made by Davie Beard, Shannon DuBose, Marietta W. Gordon, Elizabeth P. Hough, Sylvia Hudson, Mr. and Mrs. Joseph Jenkins, Paul Jeter, Mike McClendon, Carol McNaughton, Susan McMillan, Dallas Phelps, the Richland County Public Library, and Austin Sheheen.

The following historical references were used in researching this book: *Historic Camden, Volumes 1 and 2* by T.J. Kirkland and R.M. Kennedy; Annual Report by the State Superintendent of Education, 1900–1950; *Camden Chronicle*, 1890–1935; *Camden Heritage, Yesterday and Today* by Rachel Montgomery; *Kershaw County Legacy, A Commemorative History* by the Kershaw County Bicentennial Commission, 1976; and *Kershaw County Legacy Volume II*, by Glen and Joan Inabinet, 1983; Camden City Directories; and Sanborn Insurance Company's Camden Fire Maps.

INDEX